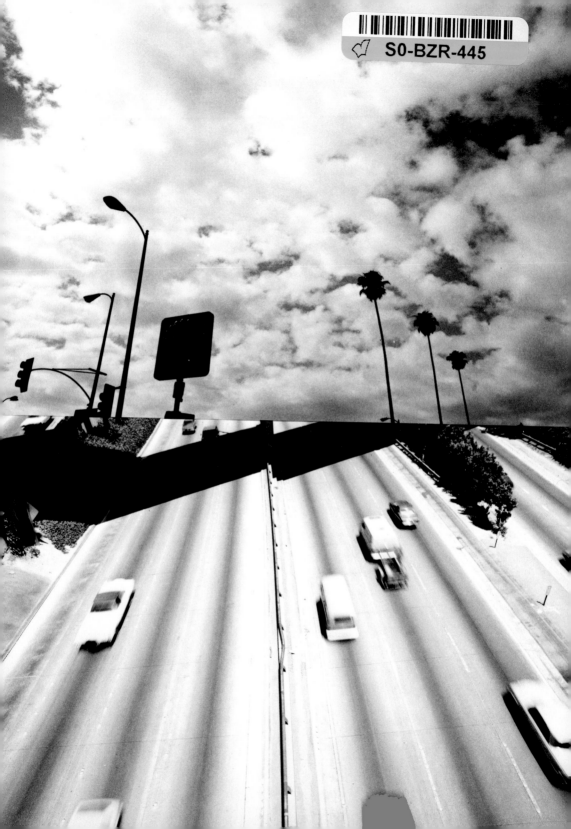

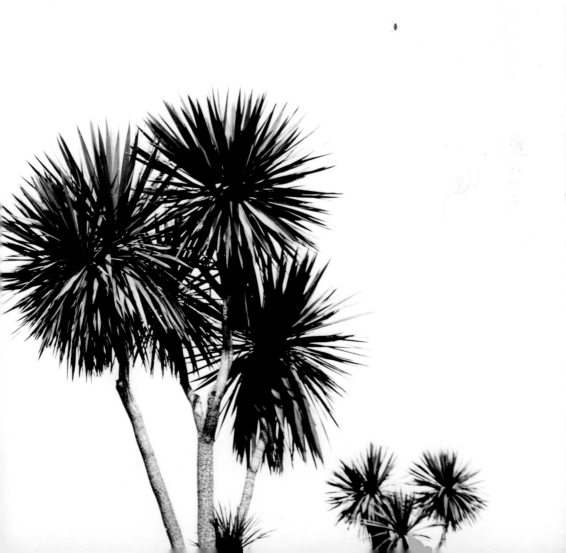

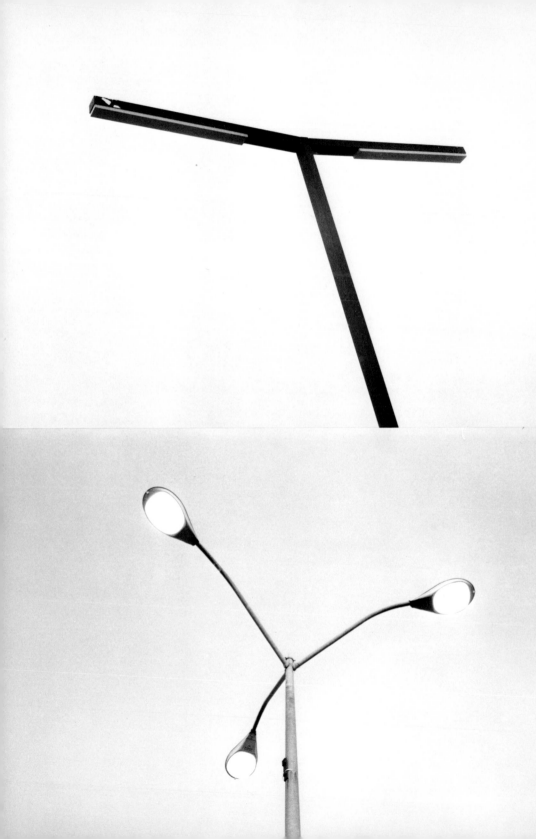

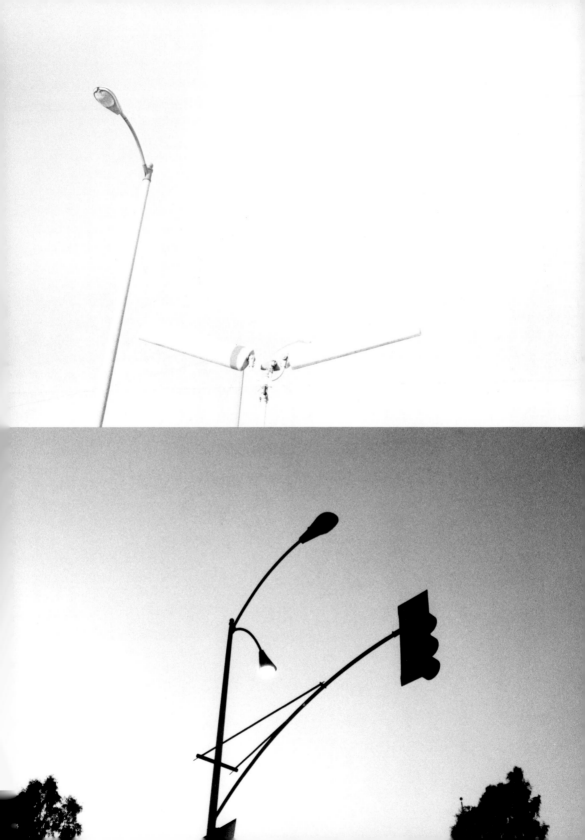

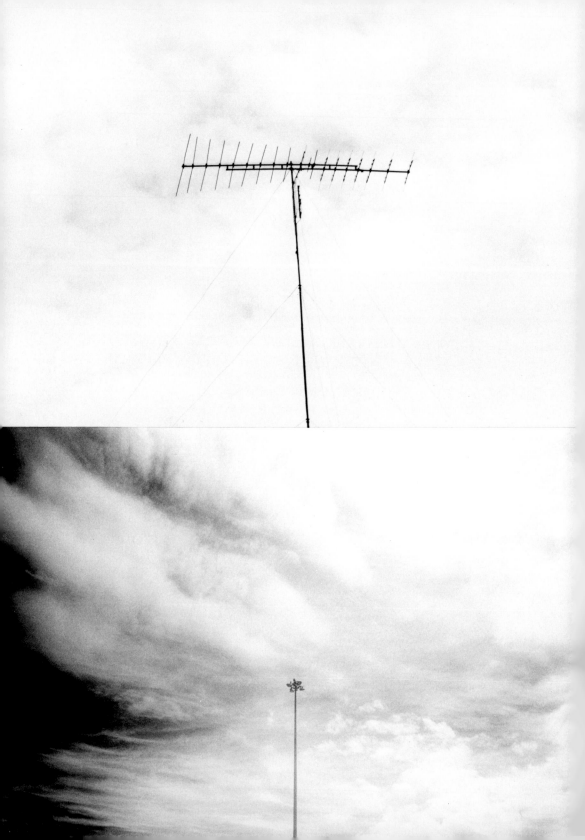

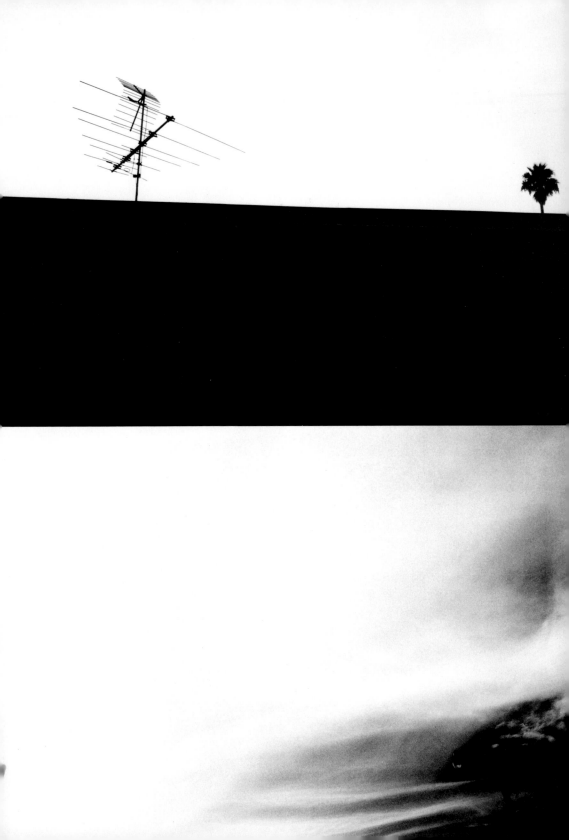

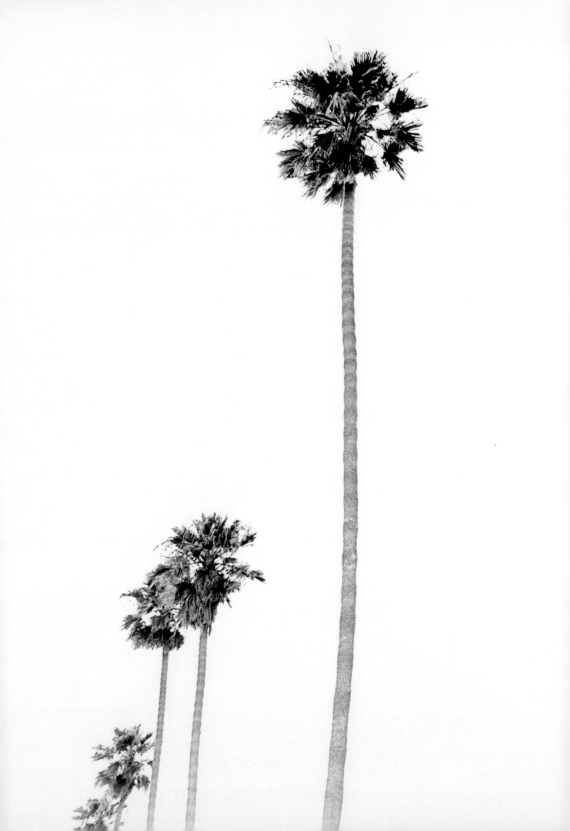

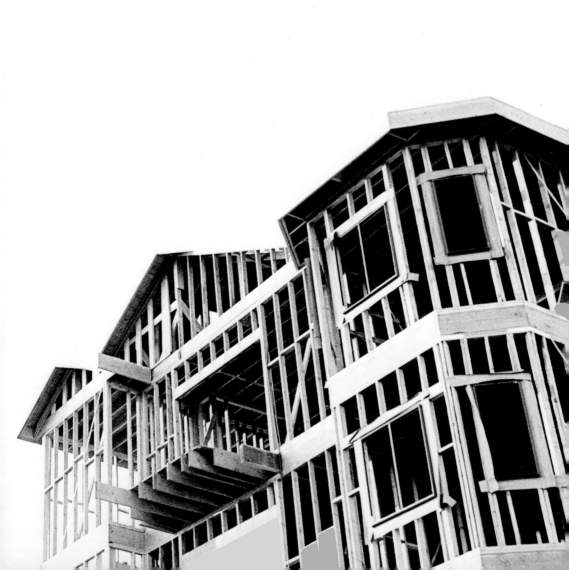

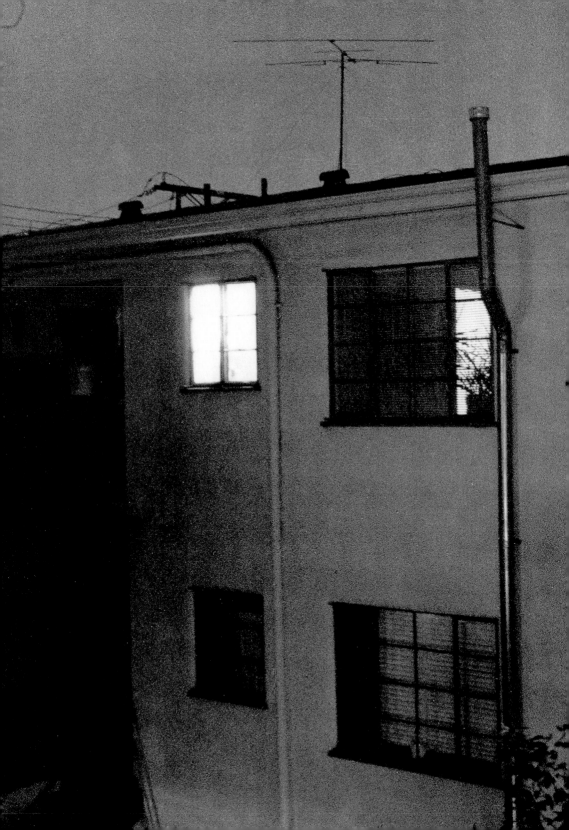

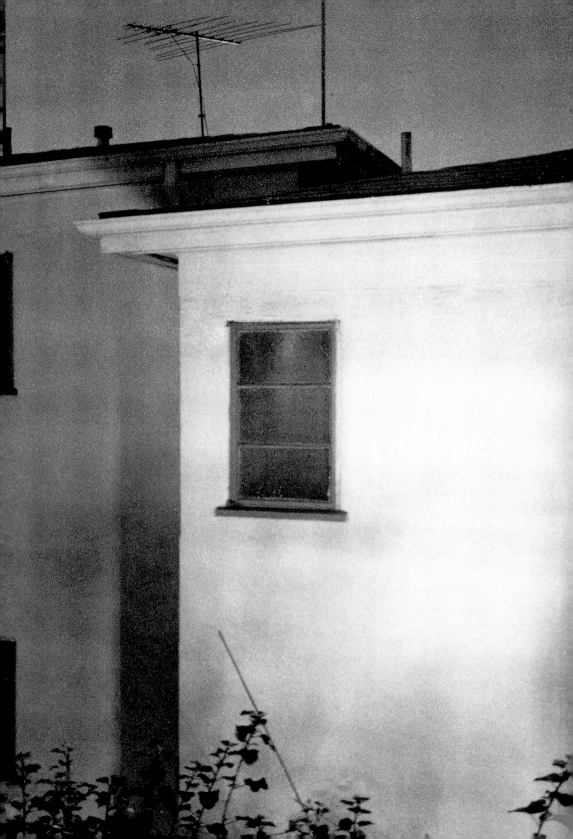

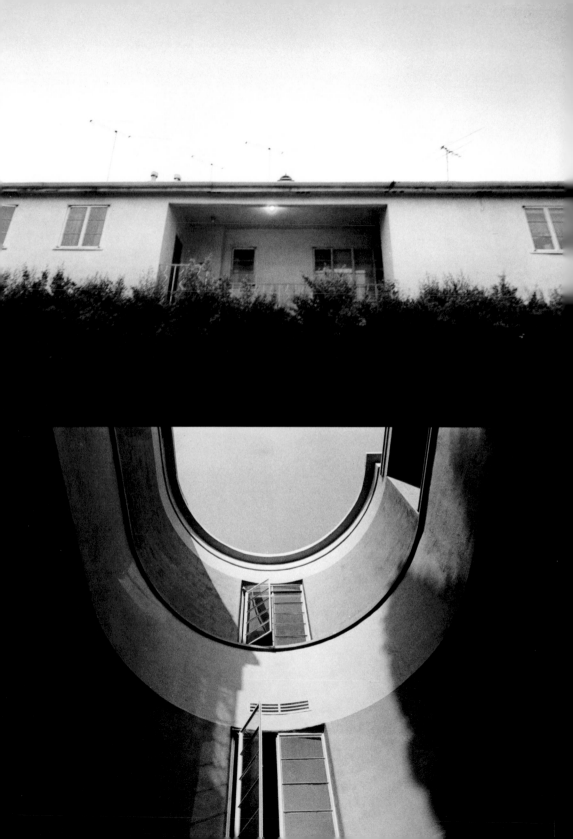

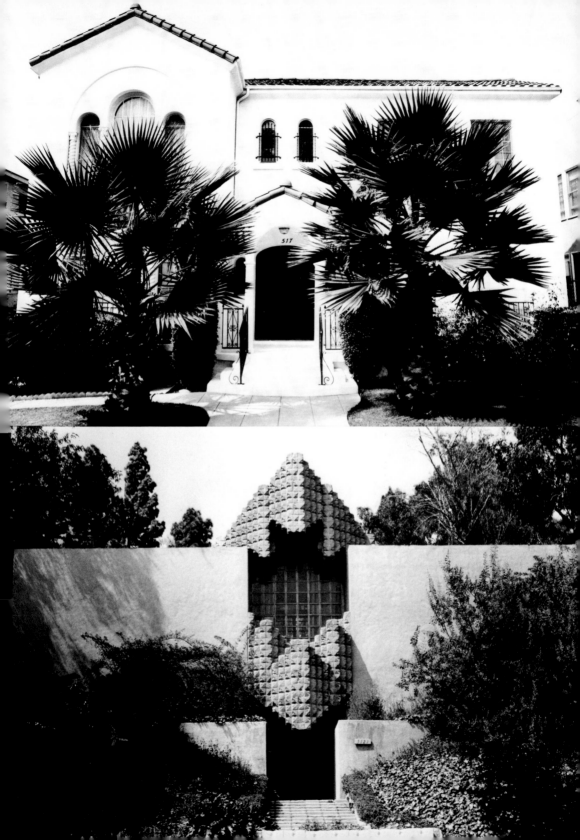

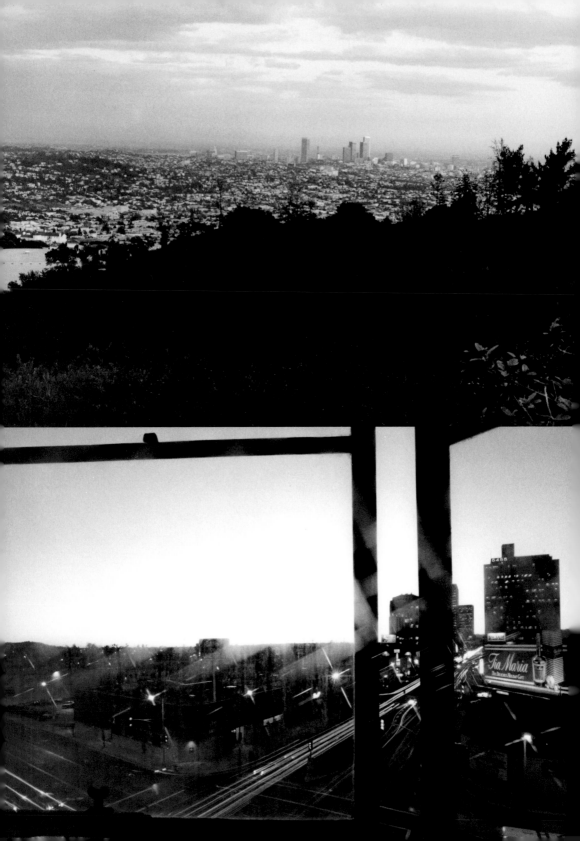

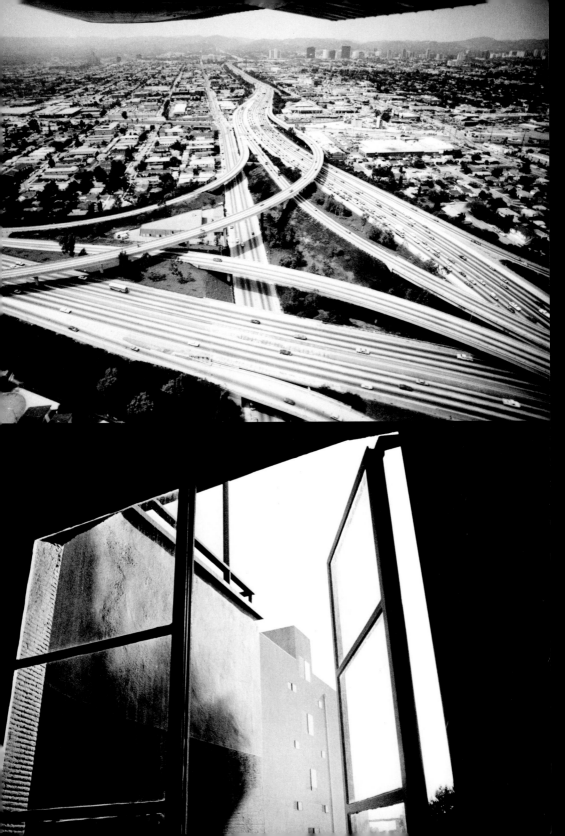

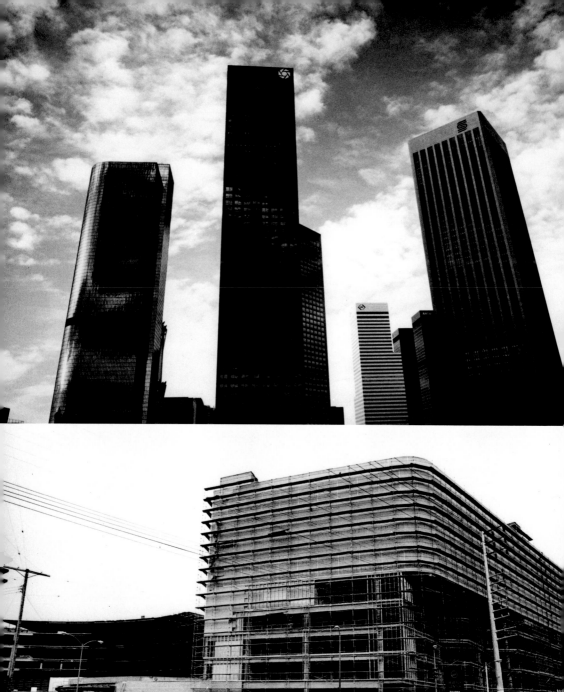

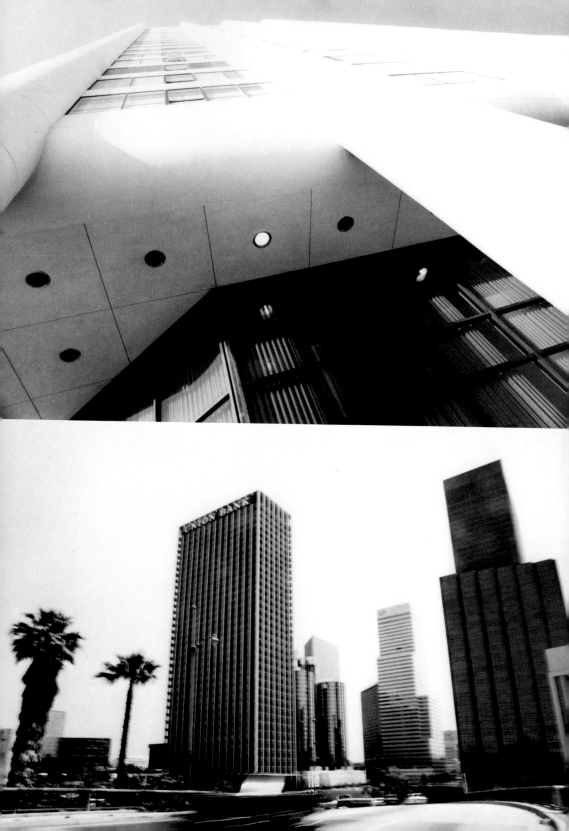

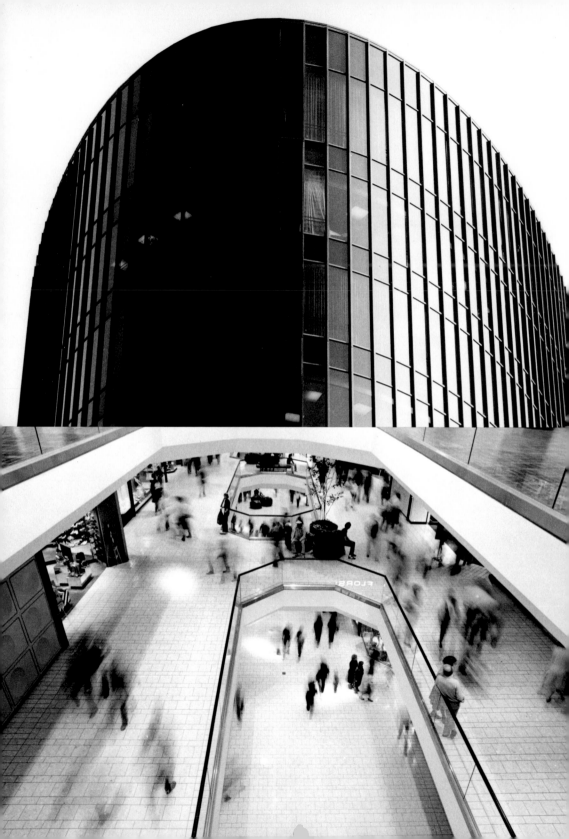

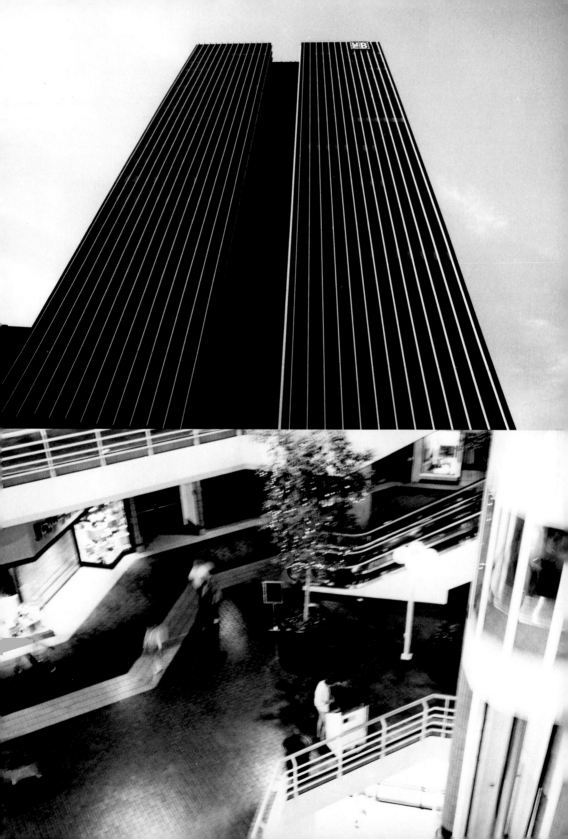

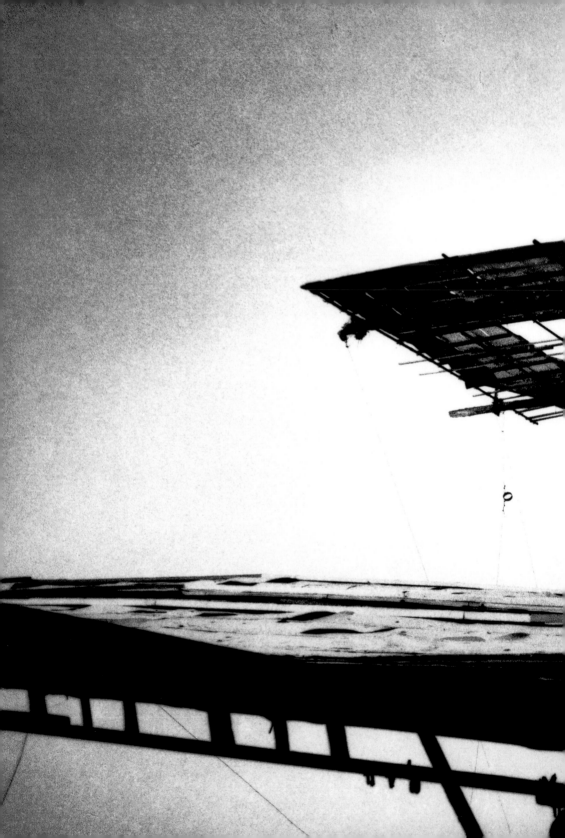

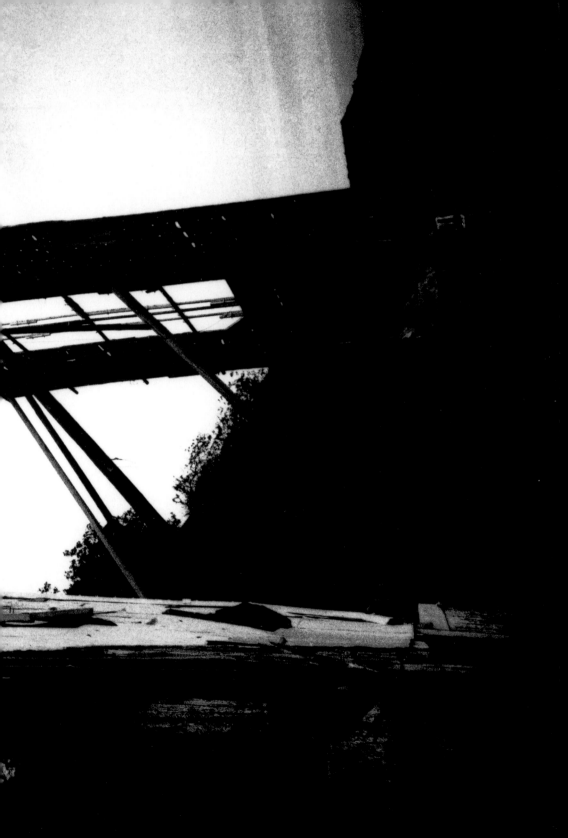

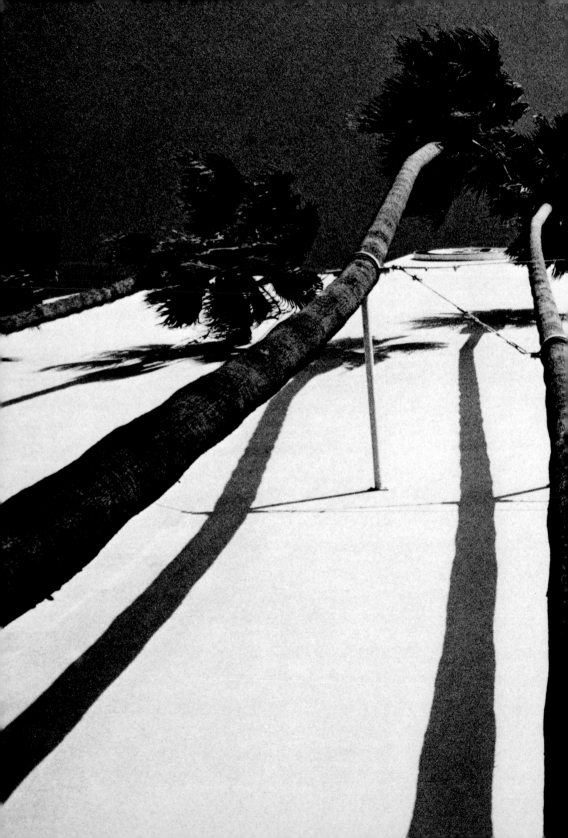

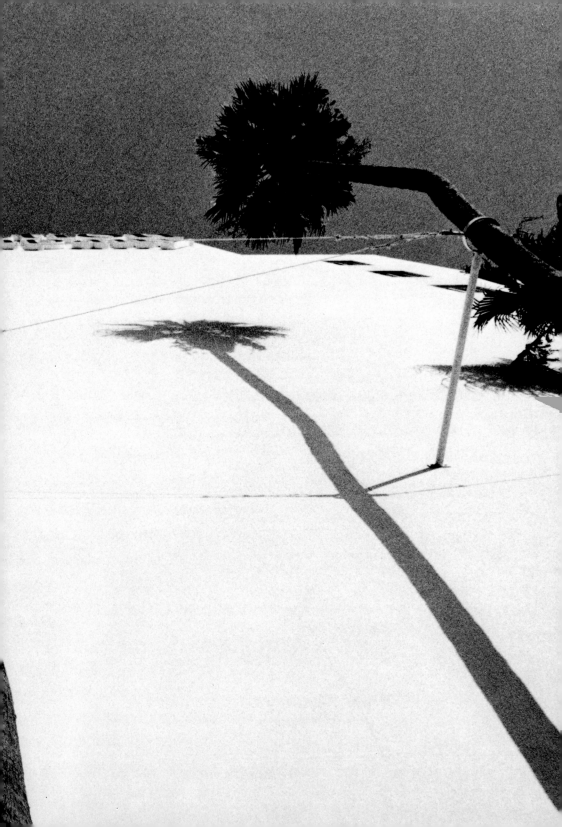

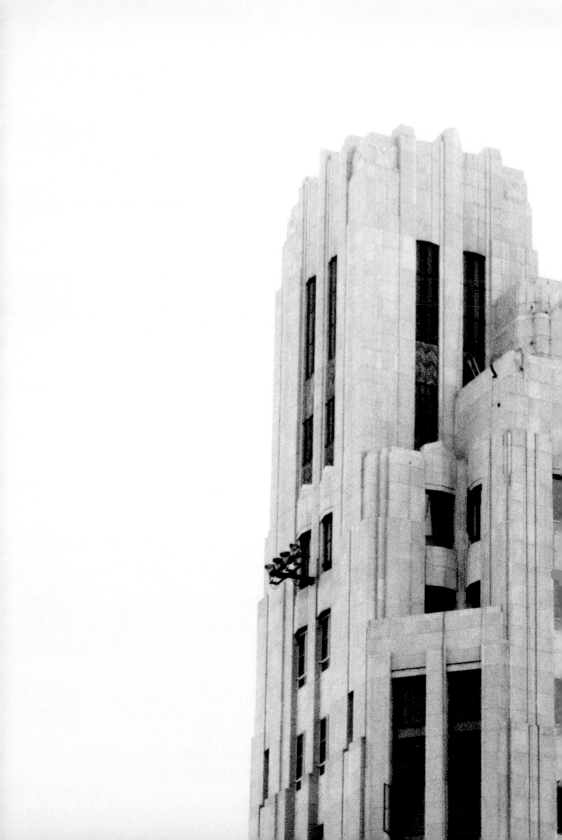

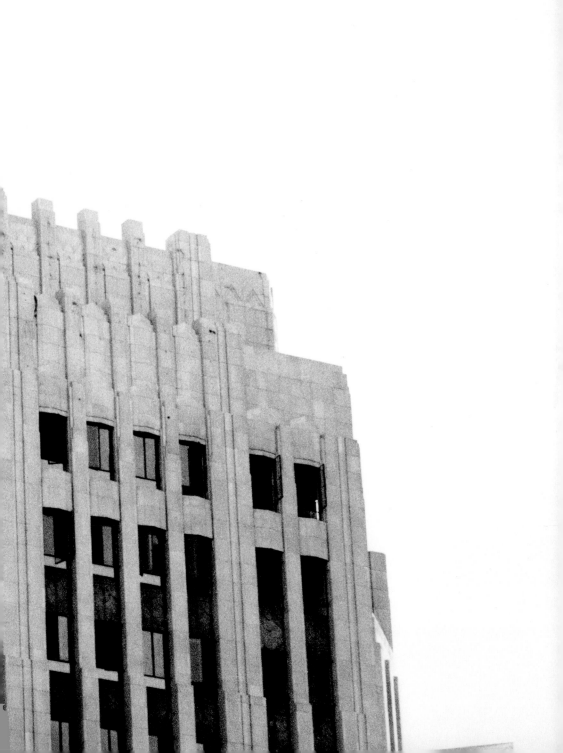

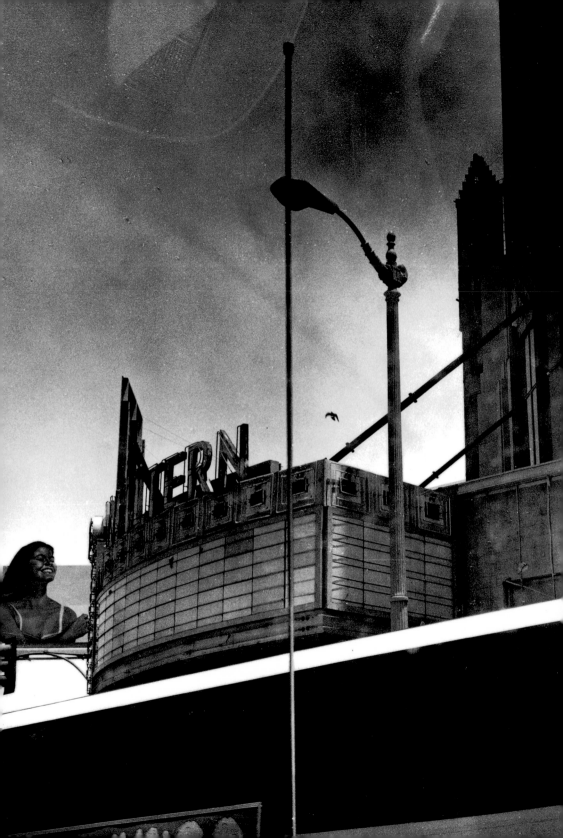

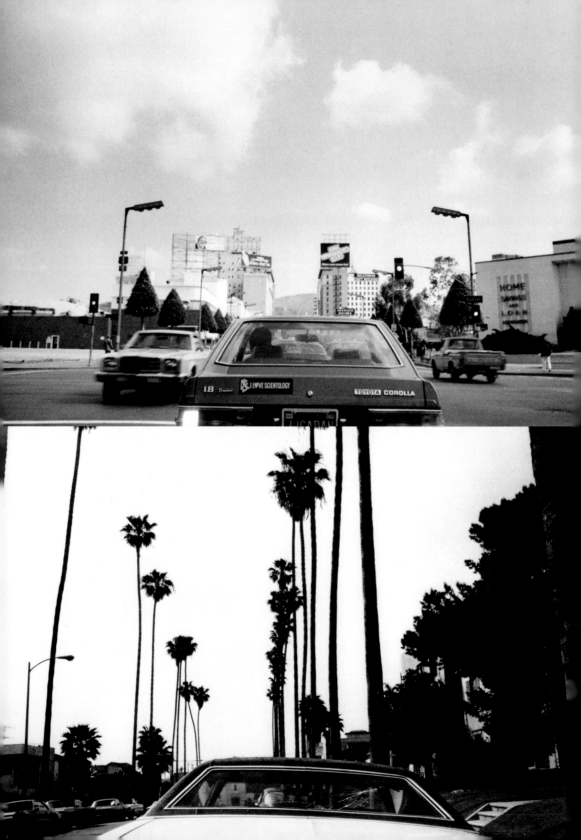

Looking for a City in America

Looking for a City in America:

An Essay by André Corboz

Photographs by Dennis Keeley

Preface by Kurt W. Forster

Down These Mean Streets a Man Must Go...

Occasional Papers from
Los Angeles
The Getty Center for the History
of Art and the Humanities,
Santa Monica
In association with
David R. Godine, Publisher,
Boston

Angel's Flight
Occasional Papers from Los Angeles

A Series of the Getty Center Publication Programs
Julia Bloomfield, Kurt W. Forster, Thomas F. Reese, *Editors*

Denise Bratton, *Translator*
Joan Ockman, *Manuscript Editor*
Lynne Hockman and Michelle Ghaffari, *Copy Editors*

Published by The Getty Center for the History of Art and
the Humanities
401 Wilshire Blvd., Santa Monica, CA 90401
In association with David R. Godine, Publisher, Inc.
300 Massachusetts Ave., Boston, MA 02115

98 97 96 95 94 93 92 7 6 5 4 3 2 1

This essay was first published in French as " 'Non-City'
Revisited," in *La Ville Inquiète*, Le temps de la réflexion,
vol. 8. Paris: Editions Gallimard, 1987.

Library of Congress Cataloging-in-Publication Data
Corboz, André, 1928–
 ["Non-city" revisited. English]
 Looking for a city in America : down these mean streets
a man must go– : an essay / by André Corboz ; photographs
by Dennis Keeley ; preface by Kurt W. Forster.
 p. cm. – (Angel's flight occasional papers from
Los Angeles ; 1)
 Translation of: "Non-city" revisited.
 ISBN 0-87923-935-2 (North American edition – Godine)
 ISBN 0-89236-211-1 (all other countries – Getty)
 1. Cities and towns – United States. 2. City and town
life – United States. I. Title. II. Series.
HT123.C6613 1992 91-14796
307.76'0973–dc20 CIP

...who is not himself mean,

...who is neither tarnished nor afraid.[1]

The latest census figures indicate that roughly half of the American population now concentrates itself in seven major urban areas of the United States.[2] Yet, as André Corboz argues so persuasively, the historic European distinction between town and country has never held on the North American continent, save in a handful of atypical instances. Instead, the practice of land division by rectilinear gridding gave rise to settlement patterns that can still be deciphered from the air as well as in the determinations of suburban lots. Heedless of natural irregularities in the landscape, a dramatic elasticity of scale attended this process and imposed a completely abstract quality on the land. The grid's concomitant ubiquity left American cities in a permanent state of indeterminacy with respect to their geographical surroundings and their internal order. Today, as this pattern is extended to connect rapidly growing communities sprouting on the open land between other towns and cities, and while the population of older centers changes wholly or decreases precipitously, the incessant pursuit of a form of settlement that is neither urban nor suburban continues at an astonishing rate.

The physically compact historic city has long been considered the crucible where the alchemy of new multiracial and multicultural life could take hold; but the reality of inner-city conditions in the United States has rarely been able to sustain these hopes. Mandated tactics of integration, like busing for school children and bilingual classrooms, stand in head-on conflict with the fiscal limitations imposed on school districts — namely, property-based taxation for the funding of education — and have consequently allowed politicians to prove unfeasible what they only reluctantly obeyed in the first place. The urban horror depicted in such films as *Blade Runner, Max Headroom, RoboCop*, and *Batman* endlessly rehearses the justification for white flight from the city and the creation of protectively isolated suburbs-without-cities, known, for example, to the weathermen of Washington, D.C., television stations as *burbs*. The climate of a *burb* is symptomatic of the constant remixing and resegregation of the population, both cause and effect of shifting sites of employment and residence, and, finally,

39

of the conditions of life *tout court*.

Corboz plunges into the realities of trans-urban existence in southern California. As he acquaints himself with the transience of American settlements through the rearview mirror and under the blaze of headlights, he also weans himself of the driving European desire for the quality of permanence in cities and for the continuity of civilization inside its man-made enclosures. These two aspects, so closely identified with each other in Europe, have never bonded in America. On the contrary, they perpetually come apart to reveal a classic polarity of home against office, dwelling against working, individual against society, identity against anonymity, and past against future. Hence the familiar (and enduring) image of an America that is always trying to look suburban. As such it possesses a ubiquity much greater than the city, a pervasive power largely independent of site, and of a more internalized than physically tangible character.

Like Antonio in Shakespeare's *Twelfth Night*, Corboz does "not without danger walk these streets."[3] He moves briskly and raises his glasses inquisitively, perhaps expressing in this gesture an unwillingness to concentrate on any one thing at a time. A shrewd observer, he not only connects *with* myriad things along his path but also connects them *to* his own rare knowledge and understanding of cities and their fates. And, like Antonio, he knows that "in the south suburb at the Elephant/Is best to lodge."[4] KURT W. FORSTER

Notes

1. Raymond Chandler, *The Simple Art of Murder* (New York: Vintage Books, 1988), 18.

2. U.S. Bureau of the Census, "Half of the Nation's Population Lives in Large Metropolitan Areas," 21 February 1991, C.B. 91–66. Figures from this recent press release on the 1990 Census Data demonstrate that half of the population of the United States lives in seven major conurbations designated by the Bureau as 'Consolidated Metropolitan Statistical Areas.'

3. *Twelfth Night, or What You Will*, III, iii, 25.

4. Ibid., III, iii, 39.

LOOKING FOR A CITY IN AMERICA

European descriptions of the American city usually suffer from three fatal flaws: they presume to understand the object of their focus; they apply to it nonpertinent criteria; they wax apologetic. We know that such an analysis will conclude with condemnation. The American city is typically construed as a boundless entity, its structure undifferentiated, its fabric monotone, its appearance chaotic. From Camillo Sitte to Leon Krier — by way of Pierre Lavedan and Le Corbusier — authors confidently perched on their disparate coigns of vantage have perceived diverse versions of the American urban agglomeration — all of them absurd. Demonstrating little interest in the social and economic mechanisms that determine such fastidious uniformity, they have contented themselves with fabricating ironic conclusions. Most of them have been inclined to believe that Americans would as readily number their cities — so completely interchangeable are they — as they do their streets, and these experts would hasten to improve matters were they only invited to do so.

Paradoxically, their rejection of the American city is contradicted by a more sympathetic attitude toward the country in general, an attitude crediting the United States with an "incontrovertible effort" and admitting that European culture is inhibiting. This sentiment finds expression in a variety of forms, ranging from self-flagellation to *sacrificium intellectus*, which prescribes the replication of American fast food, suburbs, majorettes, indifference. The European's sense of inferiority in this comparative context at times reaches a pitch so formidable that it verges on culpability, while his ritual immolation is elevated to a literary exercise. Around the turn of the century, a writer of this ilk might have spent a fortnight in the Ticino with the express purpose of producing a suite of sonnets.

In advance of a critical reexamination of the problem, all preconceptions must be suspended. For there is no more an "American" city than there is an "Asian" or "European" city. We Europeans have heretofore relied on conventions that generalize the character of urban centers, thus permitting us to disengage ourselves from them. The lack of a precise definition of the city as a contemporary, historical,

43

and transcultural phenomenon has as its ironic corollary myriad conceptions of the city — as many as there are disciplines devoted to it — and none of them is rigorous.

Until the mid-twentieth century the stereotypical conception was identified with New York; today Los Angeles — L.A. — has usurped this distinction. Whatever the emblematic identification, critics persist in avoiding confrontation with the urban reality — the very thing for which we hold them accountable. This situation worsens in direct proportion to their flagrant application of flawed criteria. In short, Los Angeles is reproached for not being a European city. At the same time, it must be admitted that American scholars have contributed very little to an understanding of the formal qualities of their cities. Two of the best-known publications are content to "play" with an assortment of reflections. *Learning from Las Vegas* by Robert Venturi, Denise Scott Brown, and Steven Izenour merely extrapolates from the most frivolous of epiphenomena, those stemming from advertising and the media.[1] *Collage City* by Colin Rowe and Fred Koetter, however stimulating, treats the urban theme with a Dadaist irresponsibility.[2] On reflection, it would seem that only Mario Gandelsonas's *The Order of the American City* lays firm groundwork for an analysis of American urban morphology.[3]

In fact, at least one author of the first rank has already called into question the prevailing criteria for evaluating the American city. Reyner Banham's *Los Angeles: The Architecture of Four Ecologies* described the shapeless conurbation par excellence with as much intelligence as amused sympathy: "So, like earlier generations of English intellectuals who taught themselves Italian in order to read Dante in the original, I learned to drive in order to read Los Angeles in the original."[4] It would, however, be exaggerating to assume that Banham's work has overcome ingrained prejudices, particularly in French-speaking regions where it has not yet appeared in translation. Reenacting the timeless role of devil's advocate, Banham left readers free to detest the "American city" while hinting at a more prudent course of action — that of first understanding it.

The intrinsic nature of the city is so self-evident to a European that he fails to see the necessity of defining its constituent elements, even though such a process would no doubt lead to a modification of perceptions he deems to be natural. Since few Europeans have had the opportunity to experience American cities firsthand, even in a random way, a relativized context for such tenaciously held perceptions is conspicuously lacking. An example: One summer morning, ten-year-old Christine and her father walk along the ancient streets of a hilltop town between Milan and Paris. After some years in America, the father is delighted to rediscover the density, the enveloping quality of an authentic place; he asks his daughter (already certain of her response) if the experience is pleasing to her. "No, there are too many houses," she replies. In technical terms, the unity of contiguous pattern and order that a European instinctively associates with the character of urban space is precisely the source of objection for this child who has grown up in a sprawling metropolis, where the intersections of streets are systematically punctuated with gas stations; where houses, isolated by random commercial development, butt up against oversized parking lots; where high-rise structures tower over ephemeral fast-food stands. That which for the father constitutes the very essence of urbanism, the daughter finds oppressive. The city, for her, is necessarily a dispersed, fragmented entity. In the face of such a reaction, any ethnocentric conceit flounders dangerously.

In spite of transformations that have irreversibly altered the urban landscape of occidental Europe during the last forty years, the native inhabitant of Milan, London, or Frankfurt relentlessly insists on the primacy of the urban center or core. Only with considerable difficulty, indeed even repugnance, does he acknowledge transformations that have turned ancient cities into regional, multinuclear entities where communal boundaries no longer respond to contemporary urban realities. Even more perverse for him is the notion of a city virtually lacking a core in the traditional sense. Nevertheless, the phenomenon occurs — with great frequency — in the United States. Porterville, California? "You drive up and down every street in the town without

being able to find anything remotely like a central point. Without even a bank, an administrative building, or a town hall, the town has no coordinates,"[5] notes a traumatized visitor. Porterville is not the exception but rather the rule the moment one moves beyond New World cities that began as British or Spanish colonial settlements: today, in these original colonial settlements what was the heart of the town has often become marginalized.

The tendency not to cherish the core of the city may express the (mythic) egalitarianism of America as it manifests itself in the built environment; it may also reflect a rigorous individualism asserting its independence from the State. Whatever the determinant causes, the decisive fact is psychological: Americans have a collective horror of the city center, in opposition to which they have posited the garden city ideal, purified of its Howardian structures and distributed across the land. (The American public categorically avoids going "into town" except out of necessity.) The *downtown* of Los Angeles, built between 1880 and 1914 and comparable to, though less diffuse than, the city centers built around the same time in New York or Chicago, is effectively censured: the marketplace only rarely offers a postcard depicting it, and it is seldom featured in aerial photographs of the city. Perceived not as a unique architectural and urbanistic entity but rather as an embarrassment, the inner city has been relinquished to Hispanic immigrants. The fact that this zone has physically deteriorated or that it has become aesthetically outmoded does not entirely explain its condemnation. Downtown has simply ceased to square with the dominant image of L.A. as a single-story town in a lush garden paradise.

If the American conurbation (for the moment there is no better description) lacks a core, it nevertheless encompasses areas of concentration. But these fail as urban spaces precisely because they perform no active role in shaping a larger urban identity, at least not yet. They are no more than protuberances in the fabric of the urban network.

Transformation of these *points de repère* into veritable urban centers would require a fundamental change in the American mentality. Such a change is astir, at least among certain privileged minorities. In

several major metropolises such as New York, San Francisco, and Los Angeles, new "vertical cities" — twenty-four-hour communities — have materialized amid older high-rise zones of the 1920s or 1950s. Not conditioned by a nostalgic harking back to the obsolete and decrepit downtown, these innovative structures are sufficient unto themselves, offering luxurious dwellings, office space, shopping arcades, and entertainment centers in varying combinations, all tightly integrated on a relatively limited surface area. Municipal governments encourage their development for fiscal reasons and real estate speculation motivates them. Developers specifically target a chosen sector of the population, namely the affluent; hence the currency of the term *gentrification* describing the social change that is the tacit goal of such a project. The significant task of "development" is affirmed not as the creation of genuine urban centers but as the installation of islands where privileged groups can encounter one another without regard for a functional relationship to the rest of the urban environment.[6] A few steps away, the old core of the city continues to deteriorate until the moment when manipulated real estate prices make "renovation" profitable. Paul Rudolph's project for the Graphic Art Center in New York (1967), a multifunctional megastructure, was the forerunner of this tendency. In other words, despite the European's infatuation with what once made up the core of the city, the hard evidence leaves intact the proposition that the core is not a determinant in urban American culture.

One could engage in an analogous discourse on the subject of public squares. With few exceptions, open spaces are laid out as quadrangles and more or less densely planted with trees, often lying directly over an underground parking lot. What Pierre Charles L'Enfant envisioned in his plan for Washington, D.C., has been applied to simple town squares; those derived from the City Beautiful Movement either submitted to this fate or were deserted.[7] Soon after the Second World War, under the influence of urban theory and based on European precedents, innumerable *plazas* were conceived with the calculated intention of stimulating commerce — a case somewhat analogous to the development of industrial design. Grandiose urban renewal

47

movements designated these to function as public places (such as the one flanking the new city hall in Boston); they turned out instead to be void spaces that were judged too dangerous even to traverse.

What to do with spaces like these is beyond the ken of a nation of people who, even in the temperate southern states, are not accustomed to congregating in the open air — neither for the sheer pleasure of being there nor out of any civic motivation (for these purposes there are ad hoc public halls). In the United States, if there does exist an animated public place, it is the street, or at least certain streets — truthfully, a rather small number of them, and even then, only at certain hours. The perpetual weekday throngs along Manhattan's pedestrian corridors are by no means paradigmatic. For the Yankee pedestrian is first and foremost a "dismounted" driver: even the jogging enthusiast is enfeebled by the power of the automobile.[8]

Having established the dearth of open spaces, the paucity of pedestrian zones, and the inconceivability of traversing an American town on foot, European critics complain about the excessive number of cars. Banham himself, describing what he humorously calls *autopia*, proposes the metaphor of Brownian movement to account for the uninterrupted flux of vehicles filling the four- to six-lane urban freeways of Los Angeles. Another author, suffering perhaps from hallucinations, witnessed "thousands of cars moving at the same speed, in both directions, headlights full on in broad daylight...coming from nowhere, going nowhere."[9] This amounts to pure semantic uproar, providing us with no information about the itineraries and motivations of American drivers, who are undoubtedly at least as rational as we Europeans. Moreover, the *raccordo anulare* in Rome and the *boulevard périphérique* in Paris would surely lend themselves to descriptions of the same grain.

Another facet of the critique assails the redundant immensity of *suburbs*, which appear uniformly alike and are thus perceived as undifferentiated. Within the greater urban system, the absence of a core to which these peripheral clusters of low buildings and dwellings can refer contradicts their definition as *sub*urban. Instead, they are

48

themselves the constituent elements of the city. Adamant rejection of the center has as its corollary a uniquely American fascination with tree-lined neighborhoods whose perimeters are defined by traffic arteries on the scale of European boulevards. The corresponding American ideal of the individual home is both quintessentially petit-bourgeois and excessively expensive to service. Yet what is most important to emphasize is that precisely this execrable ideal motivates the most lucid planners in their urban projects. Twenty years ago, Americans were described as alienated for this reason. Two-hundred-and-fifty million alienated people living in a single country would be problematic indeed.

The word *neighborhood* will doubtless seem inappropriate in this context as it designates an urban subset endowed with a certain autonomy, or at least a distinct unity within tangible boundaries — the antithesis of amorphous vastness. Nevertheless, at a glance one sees that the so-called suburb can be divided into a multitude of subunits, each having a unique social character. The "American city" is traditionally zoned according to the income levels of its inhabitants; as the city evolves, this social zoning creates in its wake a kind of "historic" zoning. Lines of contact — or of separation — between zones that at once face and ignore one another take on the contradictory functions of threshold and partition: between neighborhoods there are countless potential apertures, but there are also real barriers. Particular signs distinguish and differentiate adjacent sectors of European towns. Americans recognize them just as readily in their own towns. These passages from one milieu to another are not marked by architectural qualities primarily but rather by subtle relationships between structures and streets, distances between edifices, types of landscaping, and quality of property maintenance.

In Europe lines that demarcate the internal divisions of a town frequently coincide with the traces where two historical phases are stitched together: a boulevard that replaces an ancient fortification or row of trees, a waterway that served as a communal boundary long since abolished. Within the preestablished pattern of streets and as a

49

function of initial choices made by ancient founders or early inhabitants, the sites judged most significant continue to reap the benefits of preferential treatment.[10]

Despite the proposals made in 1893 by the City Beautiful Movement to improve the American urban morphology according to aesthetic criteria deriving from the Baroque, urbanism in America, whatever it may be, has never been keyed to figurative concerns. Instead of deriving from the familiar circle, square, or star, the American city is formulated almost exclusively on a system of orthogonal coordinates. This is its most flagrant feature, the one to which all its detractors reduce it. If the urban scheme deviates occasionally from this rule, it is because topography imposes the necessity — the pattern of development applied to the foothills north of Sunset Boulevard in Los Angeles is a case in point. More commonly, the gridiron reticulation persists even under seemingly impossible conditions, like the unyielding Divisadero in San Francisco, which clears an incline of 25 percent. These cultural motives have also produced some exceptions — Radburn and various other garden cities planned according to Raymond Unwin's principles, or the greenbelt cities of the New Deal — but these experiences have not reversed the general tendency.

As early as 1811 the guiding plan for New York City specified an orthogonal grid system, declaring it to be the most expeditious way to distribute the sprawling undeveloped land and, at the same time, to facilitate real estate speculation. This prescription was not so much incorrect as it was shortsighted: urban patterns and social topography have each come to express great diversity and have nowhere merged as a single unity. The fact that not one but several of these systems is operating simultaneously suggests that any town at least a hundred years old is a collage of fragments. Networks of streets linked in ways that confound categorization respond to a variety of tendencies; they swell then shrink in size, intersecting according to ever new modalities. It is rare that the laying out of a new planning grid is accompanied by decisions guaranteeing even a minimum of architectural unity; the blank configuration simply awaits filling in according to local zoning

regulations, which often provide little constraint. The orthogonal system gives primacy to networks of roads as well as to the basic unit of the *block*, a rectangle determined by four streets. Essentially, the pattern of the "American city" is not undifferentiated but instead "articulate" in the anatomical sense; not limitless but fragmentary; and overall, less incomplete than open-ended.

This observation leads to at least two remarks. The first is of a historical order and touches upon the origins of urban morphology; the second proposes an aesthetic evaluation of the consequences for the built environment.

As with most of the typical features of America, one must look back to the influence of Thomas Jefferson in order to understand the general conception of land in which the stubbornly persistent orthogonal grid is inscribed. A republican like Cato, Jefferson criticized the "monarchical" image of Washington; he proposed (perhaps with an eye to the Roman centuriation) a plan destined to be extended with the greatest regularity over the entire country. Thus, the egalitarianism of American society was spatially formulated. Jefferson's proposal for unifying the vast open territories of America was essentially a grid system applied in units of one square mile each. This principle went into effect with the Land Ordinance he authored in 1785, which was intended to give structure to the states of the central plains (for example, the state of Ohio was subjected to parceling as early as 1787).[11] From the air this still perfectly legible pattern reveals the ordering of the land from Texas northward to Illinois.

Compare this absolutely rational geometric conception with various other dizzying proposals of 1789, all intended to supplant former French provinces with new territorial divisions. One proposal recommended the use of multiples and submultiples of one fundamentally symbolic unit, permitting the systematic organization of administrative units from township to nation. Jeffersonian planning proceeded from a physiocratic conception of rapport between city and countryside. It had the advantage of incorporating into its scheme undeveloped portions of the landscape, an idea that had tremendous utility in

agrarian America at the end of the eighteenth century, when populated areas were utterly subordinated to productive land.

Not until the nineteenth century do we see this idea resurfacing in Europe in the work of a marginal Spanish planner, Ildefonso Cerdà. After elaborating his formulation for the enlargement of Barcelona in 1859, a plan involving a network of blocks fitted together in such a way that Jeffersonian inspiration seems probable,[12] Cerdà declared it extensible to all of Spain. Nonetheless, he conceived of his territorial grid in urban rather than rural terms. Under the invocation of *replete terram*, he became the prophet of generalized urbanization as we know it today. But Jefferson's orthogonal system underwent a similar transformation when applied to urban development. In the master plan of 1931 for Long Beach, California, it expressed itself as a connective tissue of diverse fragments, gridded but not coordinated, reaching — even at that early date — from Santa Monica to Los Angeles and from Pasadena to Santa Ana. In the more recent case of Palmdale and Lancaster, two towns straddling the San Andreas Fault, the grid system does more than fill up voids between urban fragments so as to create a coherent whole; here it becomes the armature of a future agglomeration. Immediately upon entering Los Angeles County when approaching from the north, one encounters straight avenues running perpendicular to the freeway, stretching to the west as far as the eye can see and east into the Mojave Desert. Spaced a mile apart, these thruways are designated by the letters A to S. The nearer one comes to the fault (which follows approximately the same course as Avenue S), the more numerous are the structures with enveloping walls — consistent with the now predominant practice for "earthquake-designed" housing developments.

This tendency toward walled compounds is not the only medieval tendency to be found in American urbanism. In fact, to explain certain aspects of the orthogonal system one must look for origins in precisely that historical milieu. The master plans of Oklahoma City, Oklahoma (1890), Santa Monica, California (1875), Elyria, Ohio (circa 1850), Reading, Pennsylvania (1748), and Savannah, Georgia (circa

1740), although drawn up at different times and places, share unexpected commonalities.[13] The residential block is longitudinally divided down the middle by an alley; lots are carved in narrow lateral strips perpendicular to the long sides of the block; individual houses, each separated from the next (sharing no walls), are situated at the streetside edge of the lot; and at the short ends of the block, lots are arranged facing the opposite direction. But this method of laying out residential land is not an American invention; nor does it take inspiration from the schemes elaborated by Renaissance engineers. Paradoxically, it was established much earlier: it is encountered in London in the eighteenth century, Amsterdam in the seventeenth century, Geneva in the fifteenth century, San Giovanni Valdarno in the fourteenth century, and Hildesheim in the thirteenth century. If we meet analogous structures in all of these places, it is because the Gothic tradition has persisted uninterruptedly through the centuries called "classical," at least in countries north of the Alps.

In Europe the phenomenon of densification occurred over a very long period of time; this complicates any attempt at understanding the initial stages in which the environment was built up. Occupation of land parcels coincided with demographic upsurges and was fueled by the impetus to make property profitable. At the end of a centuries-long process, dwellings four to six stories in height stood elbow to elbow. They were laid out along lateral corridors relieved only by central shafts, the incompressible residuum of unbuilt space — court and kitchen garden — that once extended to the rear of the structures. This typology survived all social, economic, and aesthetic changes. It was even reproduced in former British colonies. Whole quarters of Montreal have been designed according to this basic type; there, from the very beginning, apartment buildings were modeled on the fully developed urban forms of Europe.

In San Francisco the "Painted Ladies," celebrated as Victorian, are no less than the ultimate extension of the dwelling type found in the communal cities and fortified towns of Europe.[14] But generally speaking, in the United States, this is an exception; the process of urbaniza-

7 urbanization 53

tion usually begins each time at point zero. Densification of residential land parcels occurs rapidly, in three or four stages, and in an entirely original manner: by substitution rather than addition (instead of a linear pattern, we occasionally even find independent dwellings juxtaposed on a single parcel, a phase that immediately precedes maximum occupation).[15] Unobsessed with typological issues, American culture arrived at planning solutions piecemeal, one at a time, with an improvisational approach that stands in contrast to the rigid strictures determinant in Europe. On a "medieval" parcel in Venice, California, Frank Gehry took simple volumes as his point of departure, placing three cubes *en file* perpendicular to a street front on Indiana Avenue. On an analogous site in New York, on the other hand, Gehry elected to emphasize the longitudinal continuity of the block. While we cannot escape the conclusion that American ideas about land parceling indeed derive from Europe, in practice on American soil, they have been naturalized.

Apropos of an attempt at aesthetic evaluation, European criticism of the chaotic aspects of the "American city" generally invokes the implicit concept of harmony. From this perspective, the arbitrary sequences of voids and solids and unselfconscious juxtaposition of shockingly incompatible elements — the banal alongside the pretentious, the aggressively intrusive presence of advertising — are all summed up in a word: *ugliness.* This is rendered all the more jarring under the onus of the implicit law of "classicism," which remains little questioned. Nevertheless, it is necessary to declare the contingency of this conception. Classicism — more precisely, Neoclassicism — should not be seen as a given but rather as a dated cultural ideal taken up by a conservative and passionately idealistic society. In appealing to the supreme law of harmony as a way of exorcising the sins of Yankee "builders," critics fail to take into account the essential rupture inherent in the Cubist revolt against the aesthetic standards of earlier periods, not to mention that of Pop art, Minimal art, Arte Povera, and everything the avant-garde (absolutely anticlassical in its essence) declared about the modern world.

54

In recalling these basic truths, I do not wish to depict the urban American reality as admirable but only — must I repeat? — to demonstrate the instances where we have inappropriately applied our automatic criteria. To regret that Los Angeles is not Bruges or Viterbo is tantamount to playing gin rummy according to the rules of *belote*. The essential risk is that the Hearst Castle will be mistaken for the Escorial.

Misunderstandings about the "American city" stem from misconceptions about the American mentality that produced it. The American, such as even an informed European imagines him, is too often a figure drawn from myth. For example, there is the myth that he is mobile because he has no roots: "It poses no great problem to transfer an American from Colorado to Georgia, for he lacks historical memory; on the other hand, in Europe, it is difficult enough to transfer someone from Milan to Rome, so different are the respective lifestyles," notes an Italian business executive.[16] In reality, the American firmly perceives himself to be a citizen of a certain state, even of a precise locale, and he is "proud of it." Equally great differences exist between natives of Rhode Island and Texas as between those of Stockholm and Madrid. If the American accepts an offer to move from Wyoming to Connecticut, it is surely not because these places are for him interchangeable. And if he is in fact more mobile than his European counterpart, this is because he gives priority to his profession above all other considerations and also because he has not yet become irreversibly sedentary.

Another myth involves American historical amnesia. If there is a shred of truth in this notion, it is difficult to comprehend why even the faintest evidence of the past tends to leave an indelible impression on the country — the memory of Paul Revere's famous midnight ride of 1775, engraved in the pavement of Boston's modern streets; the arrow-strewn paths of wagon trains that crossed the Old West and the still-intact footpaths winding through the deserts of the Southwest; the multitude of edifices and sites declared "historic," carefully maintained and respectfully attended. It is perhaps not even unreasonable

55

to speak of patrimonial fetishism: in the United States the very traces of ancestors are worshiped.[17]

Americans are truly united by their history, so securely do they feel that they belong to a single historical cycle. This is no longer the case in Europe, where the historical processes that culminated in nineteenth-century nationalism have ground to a halt. To compensate for the relative brevity of their historical past, Americans skip over the millennia — not to mention the indigenous Native American cultures — and attempt to link themselves directly to geological time, narrating the phases of the continent's formation in the same manner as they do the Battle of Gettysburg.

The Declaration of Independence of 1776, even more than the Constitution of 1787, sets forth the mythic origin of the United States. The latter informs, in its turn, the great unifying myth of the "melting pot," the propriety that enabled America hastily to transform immigrants into citizens. Millions of Irish, Italian, and German emigrants willingly departed from their native countries to integrate themselves in the promised land. Yet it would seem that this integration was not complete until the third generation (as everywhere, assimilation is achieved only when grandchildren cease to speak the language of their immigrant ancestors). It is, moreover, interesting to note that the ideology of the melting pot finds an earlier sanction in the writings of Charles Darwin, whose *Origin of Species* (1859) appeared at just the right moment to provide a moral basis that would support the bourgeoisie in its conquest of the planet. The individualism that prevails today among Americans does not preclude their marvelous capacity for uniting when an event or issue threatens national pride or is perceived to do so. Recent crises have amply demonstrated the truth of this observation. Above all, theirs is a gregarious individualism. The narcissistic individual with his anxiety about performance, his conduct exempt from any metaphysical pathos — the last avatar of would-be natural selection — keeps alive one of the only traditions still found in the United States as a whole: the pioneering spirit.

The pioneer's principal problem is survival. He adjusts to the most

LOCAL VS.
BIG BOY

uncomfortable situations, he improvises, and he relies upon no one
but himself. He exists without a sense of authority. His cities resemble
him: they have a provisional character and respond to the ephemeral
present in the most direct way. "Move along." This phrase must be
taken literally: to change is to progress. In such a setting, there is no
place for the abstract. The public and private blend; each person is
a law unto himself, and a sense of civic responsibility is remarkably
absent. The State, so utterly remote and lacking a concrete identity, is
perceived as feeble. Today it is your "major" credit card — even
without a photograph — that guarantees your official identity.

Such is the mentality that has given birth to modes of occupying
the land not comparable to those employed in Europe. And in this sense,
can it really be said that Europeans are capable of being objective
about their own cities? In fact, nothing could be less certain. Beyond
demonstrating how criticisms of the "American city" fall short of their
goals, the point must be made that these critiques take as their point
of departure a "European city" that no longer has a raison d'être.

With the exception of certain metropolises whose development and
mushrooming growth date from the nineteenth century, cities implicitly
taken as touchstones originated before the Industrial Revolution.
The exaltation of an extinct city would be less of a deception if it took
into account manufacturing zones, working-class housing, and works
of civil engineering as essential elements of — and vigorous witnesses
to — the urban entity in the process of becoming.

Europeans worship the core of the city, that which was spared
destruction during the war but has since suffered, and considerably
more radically, from renovation. Towns that escaped the ravages of
the two wars now choose between a tourism that denatures them and a
squalor that degrades them. In countless examples the core is but a
pathetic fragment of the modern urban system, its population negligi-
ble in comparison with that of the region by which the town as an
entity has been engulfed. Even if the centers remain intact, their struc-
ture and limited surface area prevent them from fulfilling a valid
guiding function. One also observes that motorists entering many

historic city centers of Europe experience extremely unpleasant first
impressions, prospects from the highways being nearly as ugly as they
are in American cities: Vicenza, Clermont-Ferrand, Zurich, Würzburg,
or Liège offers no less chaotic an appearance than Dallas, Boston,
or San Diego (perhaps it is even *more* difficult to drive into the
European city).

Europe now bears a paradoxical resemblance to exactly what it
claims to despise across the Atlantic Ocean. Once unique, its forms have
been diluted or, worse, survive under the cover of *maquillage*. We
can ridicule Twentynine Palms, California; Bismarck, North Dakota;
Saint Cloud, Minnesota; Murfreesboro, Tennessee; Pocomoke City,
Maryland; Holbrook, Arizona; and a thousand other cities, which
Lewis Mumford referred to as no more than postal addresses, but only
on condition that we do the same thing with obscure French villages
like Cergy-Pontoise, Saint-Quentin-en-Yvelines, L'Isle-d'Abeau, and
indeed even Maubeuge or Annemasse.

On the point of historical fetishism, one may raise the objection —
and with justification — that this has nothing to do with history in the
pure sense. Yet alas, I fear, that the urban history of Europe too will
follow Arthur Rimbaud's path of the ancient parapets, where history
is reconceived as a "structured tradition guaranteeing the continuity
of the future,"[18] though it no longer constitutes a critical reconstruc-
tion of the past. Instead of mocking knee-jerk references to the fathers
of the American Constitution, to Abraham Lincoln, to Franklin D.
Roosevelt, or to John F. Kennedy, one would do well to acknowledge
that Vercingetorix, Joan of Arc, and the kings who have shaped the
history of France are endowed with an even more totemic character.

Obstacles stemming from lengthy occupation of the soil now pre-
vent Europeans from seeing the future clearly, or from simply respond-
ing to the march of time; this phenomenon has no parallel in the
United States. Out of El Pueblo de Nuestra Señora Reina de Los
Angeles de Porciuncula (which two centuries ago covered no more area
than the Place Vendôme) issued an urban surface that today, super-
imposed on the site of Paris, would extend from Mantes to Provins and

from Melun to Beauvais. The same observation can be made about Chicago — a settlement that began with twelve cabins in 1832 and grew to more than seven million inhabitants in 1980 — and about innumerable other metropolitan centers.[19] This exponential growth has had impact on the internal workings of cities throughout the country. In the new network without interstices, the old urban surfaces assume the role formerly played by villages and burgs in a feudal state. The eruption of skyscrapers has also altered the order of magnitude, adding to the whole a density that transforms the hierarchy as once did massive cathedrals towering over the low profiles of Romanesque cities. The San Gimignano of the downtown, which Manfredo Tafuri has described as a disenchanted mountain, seeds a diaspora of new sites and multiplies the focal points of the immense assemblage, transforming it into a megalopolis seen through the lens of smog. A similar phenomenon characterizes systems of public transportation thoroughfares: urban freeways shape the city's larger dimension by superimposing themselves on the network of local streets and roads.

I have refrained from using the word "waste," from accusing the urban populations of political illiteracy, or from indicting city administrators for epistemological insolvency. Perhaps I would do well to emphasize one last time that the point of my argument is not to portray the divine character of Kansas City or of Tallahassee but only to draw attention to a common error of evaluation. Although we Europeans belong to a cultural family capable, at least until recently, of analyzing urban problems and deducing theory from them, our efforts are fraught with banality: "Our concept of the city is associated with a specific way of life that has been modified to such an extent that, as a concept, it cannot survive the change."[20] Any credence given to the European critique of the "American city" is above all a projection of European bad conscience. Europe's towns have reached their apogee as urban form but have not yet found their regional identity. They oscillate now between these two dimensions, and almost everywhere have abandoned themselves to a repugnant and dehumanizing *warehousing of human beings.*

59

Notes

1. Denise Scott Brown, Robert Venturi, and Steven Izenour, *Learning from Las Vegas* (Cambridge, Mass.: MIT Press, 1977).

2. Fred Koetter and Colin Rowe, *Collage City* (Cambridge, Mass.: MIT Press, 1978).

3. Mario Gandelsonas, *The Order of the American City* (Princeton: Princeton Architectural Press, 1986).

4. Reyner Banham, *Los Angeles: The Architecture of Four Ecologies* (New York: Penguin Books, 1971).

5. Jean Baudrillard, *America*, trans. Chris Turner (London and New York: Verso, 1988), 65.

6. Cf. Domenico Cecchini and Maurizio Marcelloni, "Centro e periferia della nuova città in U.S.A.," *Urbanistica* 80 (August 1985): 50–54.

7. The Bible of the City Beautiful Movement is Werner Hegemann and Elbert Peets, *The American Vitruvius: An Architect's Handbook of Civic Art* (New York: Architectural Book Publishing Co., 1922). For further reference see Giorgio Ciucci et al., *The American City from the Civil War to the New Deal*, trans. Barbara Luigia La Penta (Cambridge, Mass.: MIT Press, 1979), esp. 46ff.; and David Schuyler, *The New Urban Landscape: The Redefinition of City Form in Nineteenth-Century America* (Baltimore: Johns Hopkins Univ. Press, 1986), passim.

8. Cf. Bernard Rudofsky, *Streets for People: A Primer for Americans* (Garden City, New York: Doubleday, 1969).

9. Baudrillard (see note 5), 125.

10. On the problem of limits, identified by Kevin Lynch, *The Image of City* (Cambridge, Mass.: MIT Press, 1960), but little studied from the point of view of the project, cf. Franz Oswald, "Phänomen Grenze," *Zürcher Almanach* (1972): 1–12.

11. Cf. Paolo Sica, *Storia dell'urbanistica* (Rome: Laterza, 1976), vol. 1, *Il Settecento*, 366ff.

12. Cf., for example, the plan of Jeffersonville (1802); see John W. Reps, "Thomas Jefferson's Checkerboard Towns," *Journal of the Society of Architectural Historians* 20 (October 1961): 109, fig. 1.

13. Cf. John W. Reps, *The Making of Urban America: A History of City*

Planning in the United States (Princeton: Princeton Univ. Press, 1965).

14. Cf. Anne Vernez Moudon, *Built for Change: Neighborhood Architecture in San Francisco* (Cambridge, Mass.: MIT Press, 1986).

15. Cf. Pierre Mouton, "Maisons de ville à Los Angeles: Un nouveau mode d'habitat?" *Architecture-Mouvement-Continuité* 13 (October 1986): 10ff.

16. Carlo De Benedetti, *L'Espresso* (14 December 1986): 50.

17. In Texas there is a Lyndon B. Johnson National Historical Park that features the Johnson ranch, the Texas White House, the family cemetery, the home of the grandparents, and the reconstructed house in which the former president was born; by bus, the tour takes ninety minutes.

18. Jürgen Habermas, "La Modernité: Un projet inachevé," *Critique* 413 (October 1981): 953.

19. Cf. Blake McKelvey, *The Urbanization of America, 1860–1915* (New Brunswick: Rutgers Univ. Press, 1963); and idem, *The Emergence of Metropolitan America, 1915–1966* (New Brunswick: Rutgers Univ. Press, 1968).

20. Jürgen Habermas, "L'autre tradition," in *La Modernité, un projet inachevé: 40 architectes*, exh. cat. (Paris: Editions du Moniteur, 1982), 30.

Dennis Keeley was born in 1952 in New Jersey. His father and grandfather were both accountants. He fled a life of business for California in 1971 and settled in Los Angeles. He has worked as a musician and photographer and sees his art as a process of exploration and response to the local environment.

"These pictures are not conceived but are discoveries. I seek to be a witness at these events, trying to reveal a speciality in these moments that would otherwise go unnoticed. I like to think that I am just the caretaker of the truth in these pictures — offering not an enhancement but simply a presentation of this vision."

André Corboz was born a Swiss citizen in 1928 on a rainy day in a rainy country. He married (just once), has a son in northern Quebec and a daughter in France. He believes that he zigzagged his way from an administrative role at the University of Geneva to a thirteen-year stint as professor of the history of architecture at the University of Montreal, and then back to his native land in 1980 to assume the chair of urban history at the Federal Polytechnic Institute in Zurich. Clearly, a zigzag to a Swiss could very well be another man's straight line.

In his study of cities, Corboz has explored a variety of methodological paths around the globe. His provocative insights into urban phenomena are laid down in his books — *Invention de Carouge, 1772–1792* (Lausanne, 1968); *Peinture militante et architecture révolutionnaire: A propos du thème du tunnel chez Hubert Robert* (Basel, 1978); *Canaletto: Una Venezia immaginaria* (Milan, 1985); *Stadt der Planer, Stadt der Architekten* (Zurich, 1988) — and a veritable harvest of articles and essays in both pioneering journals and long-established scholarly periodicals.

As a Getty Scholar during 1986–1987, he rediscovered America from the western edge of the continent. He is a frequent participant at symposia and conferences — especially if they are held in Italy. He resides on the lakefront near Zurich, drives a Peugeot, loves music without making any himself, and has the nose of a fox delicately balanced with the temperament of a hedgehog. — K.W.F.

Looking for a City in America:
Down These Mean Streets
a Man Must Go...
An Essay by André Corboz
Photographs by Dennis Keeley
Designed by Bruce Mau with
Alison Hahn, Kathleen Oginski and
Nigel Smith
Composed by Archetype
in Baskerville and Futura
Printed and bound by
The Stinehour Press
on Mohawk Vellum Text, Monadnock
Caress, and Warren Lustro Dull

Angel's Flight.
Occasional Papers from Los Angeles.
Series designed by Bruce Mau

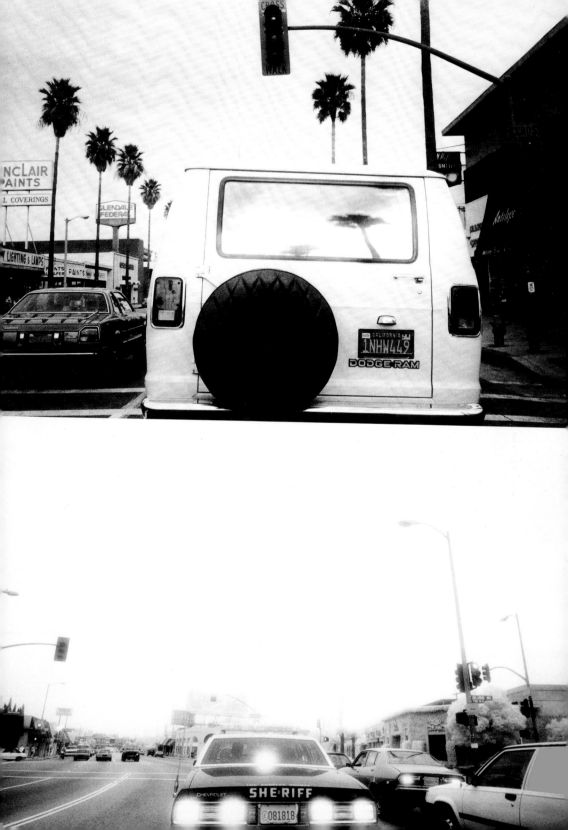

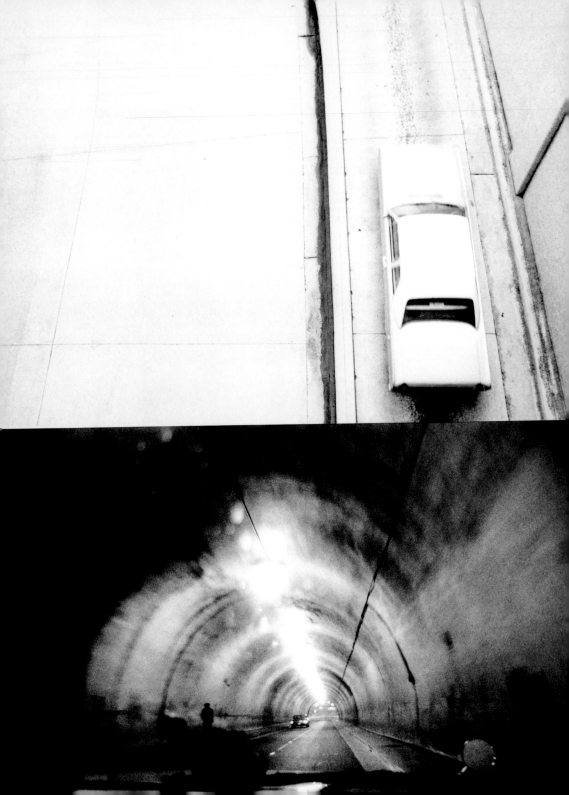

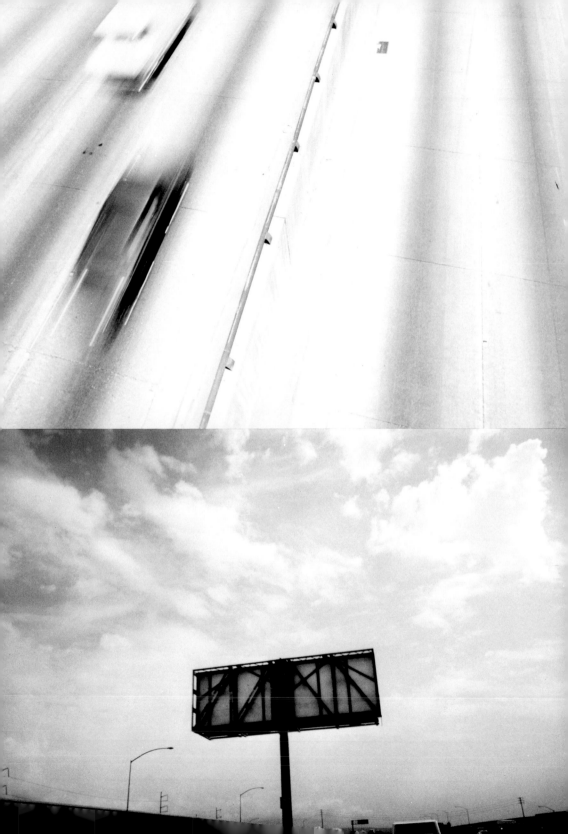

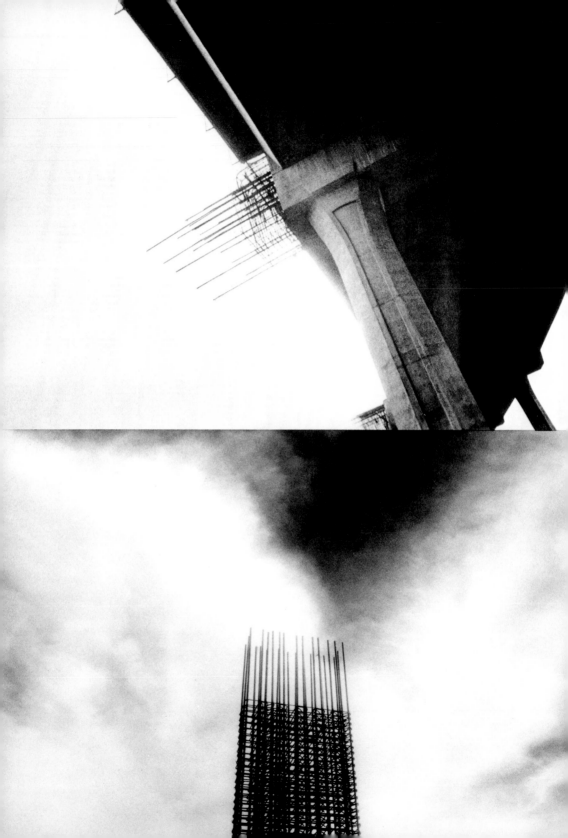

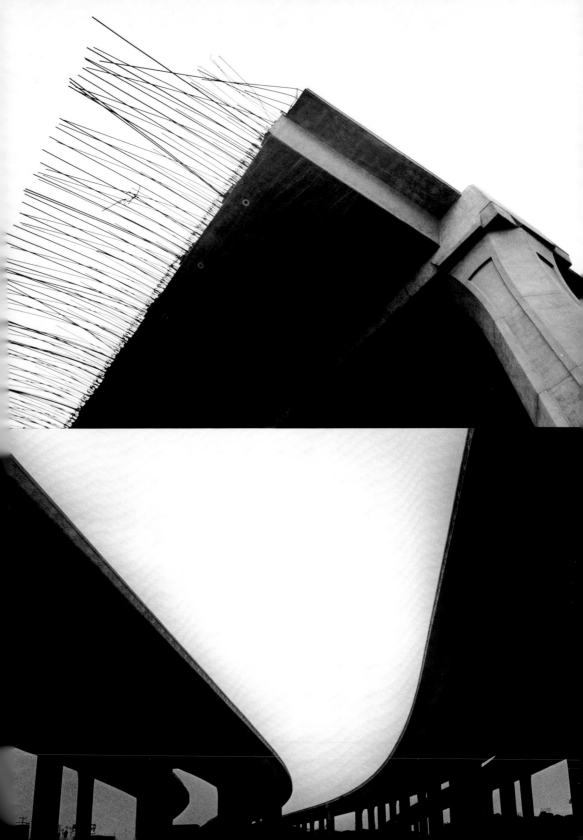

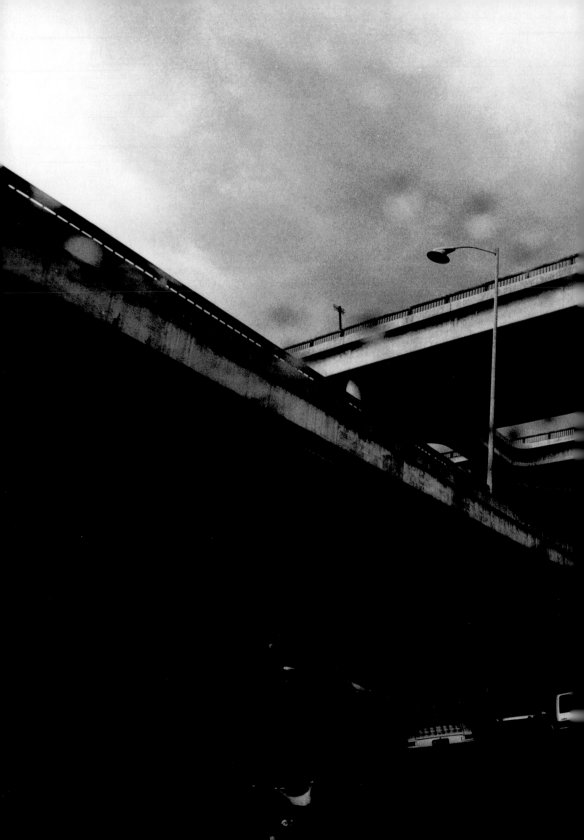

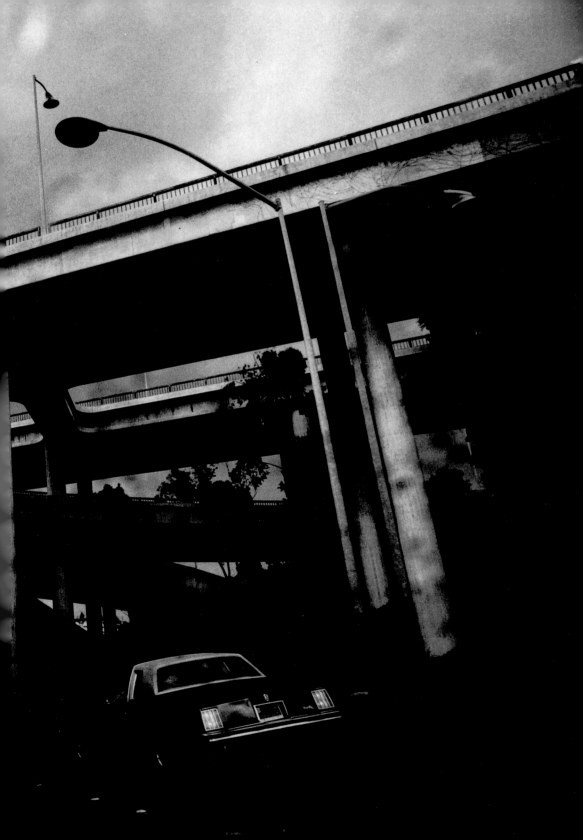

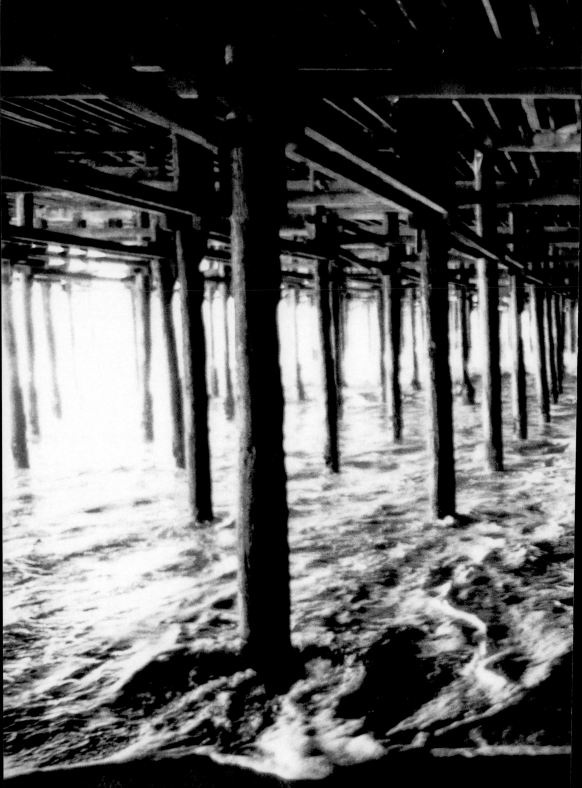

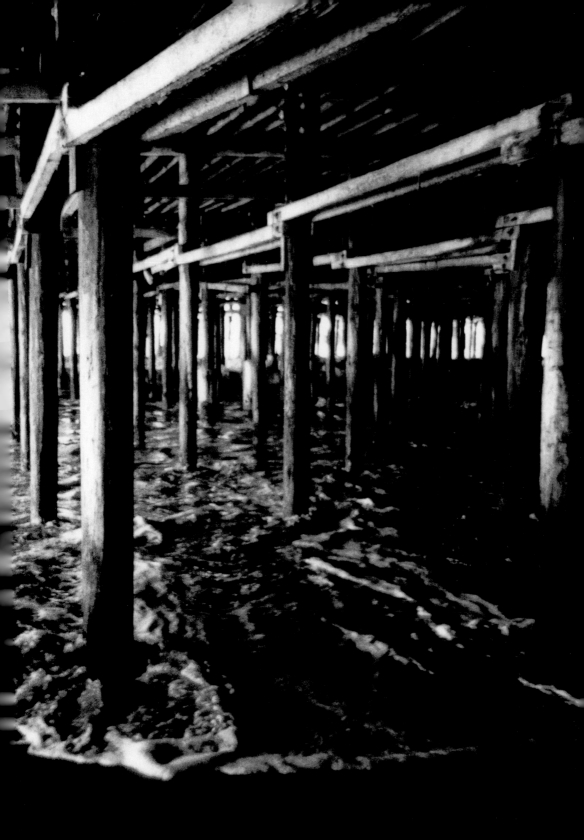

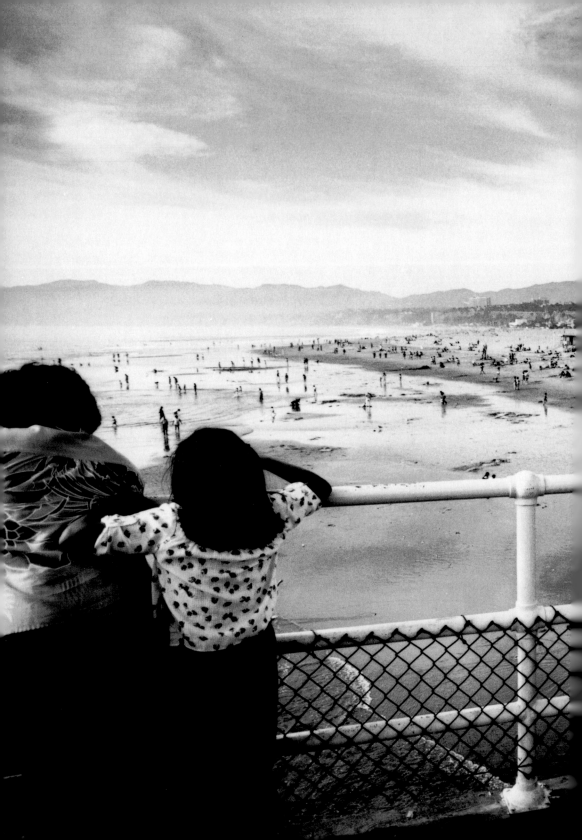

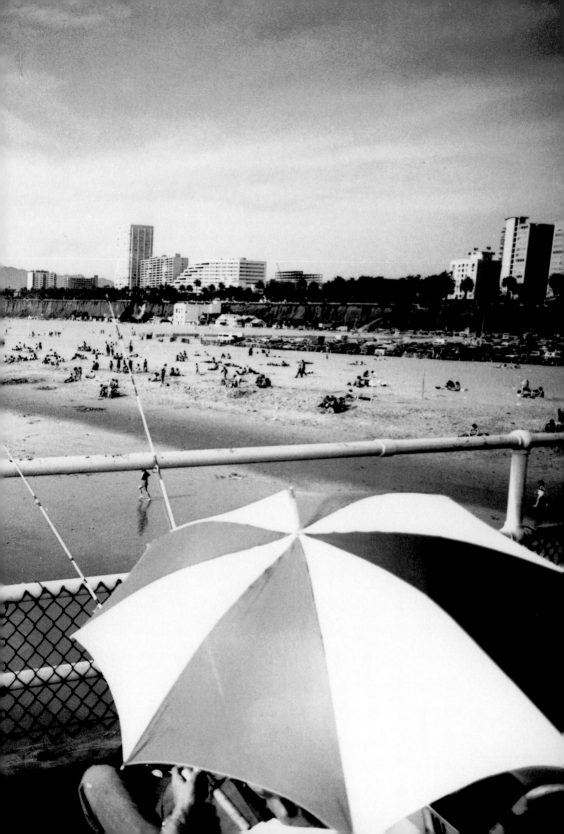

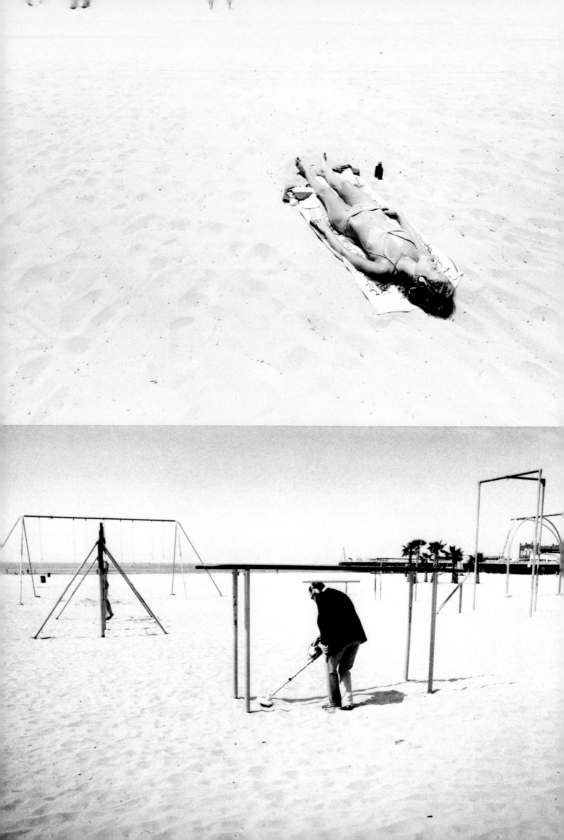

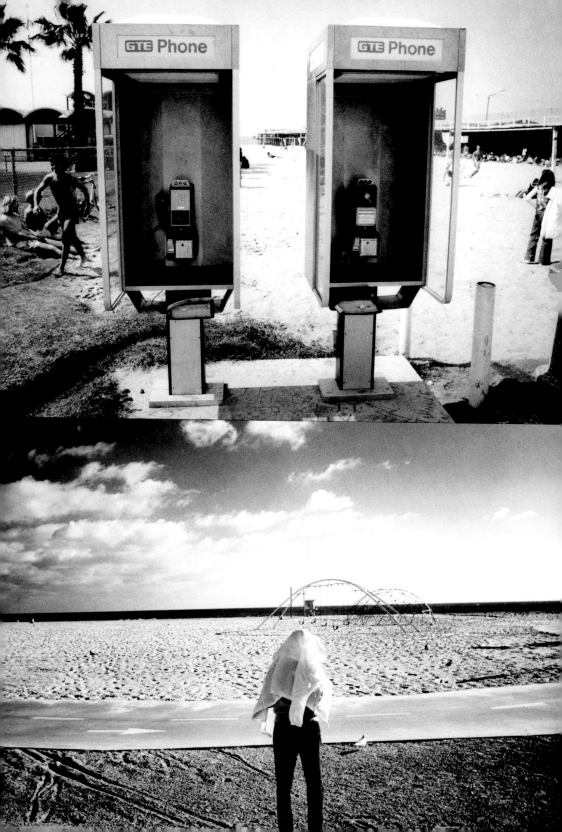

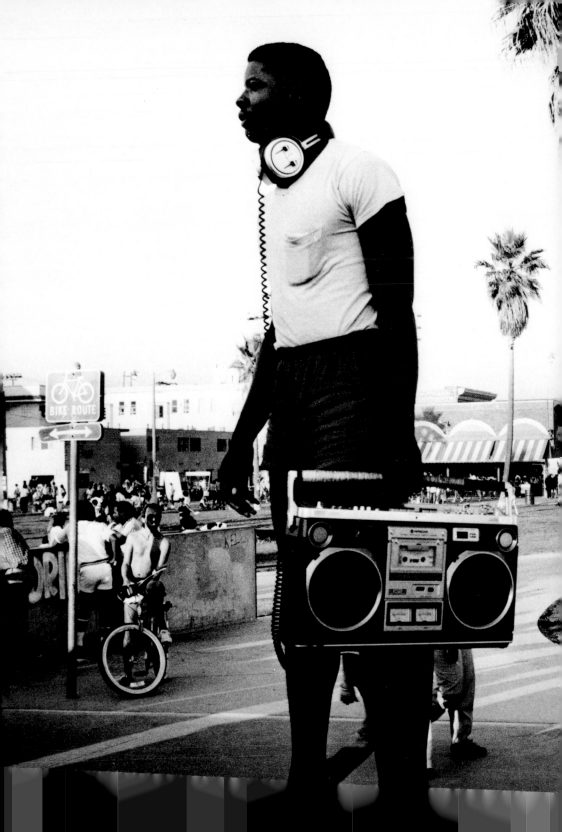

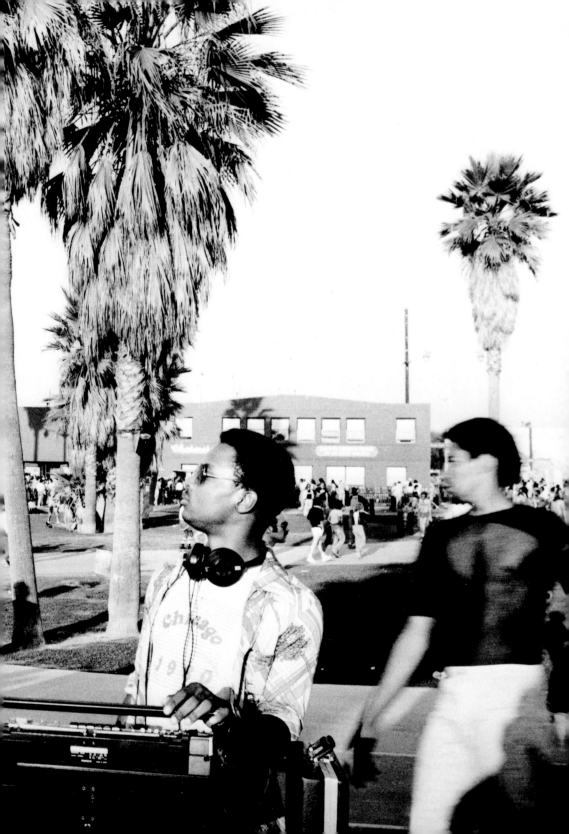

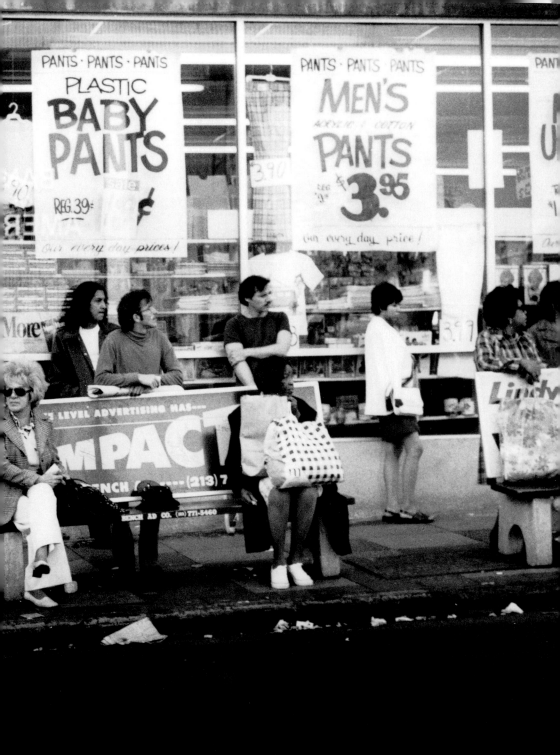

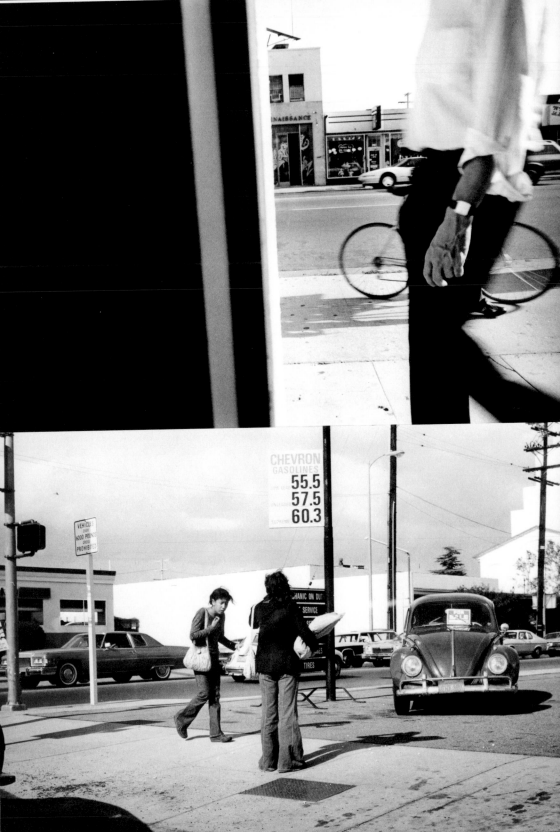

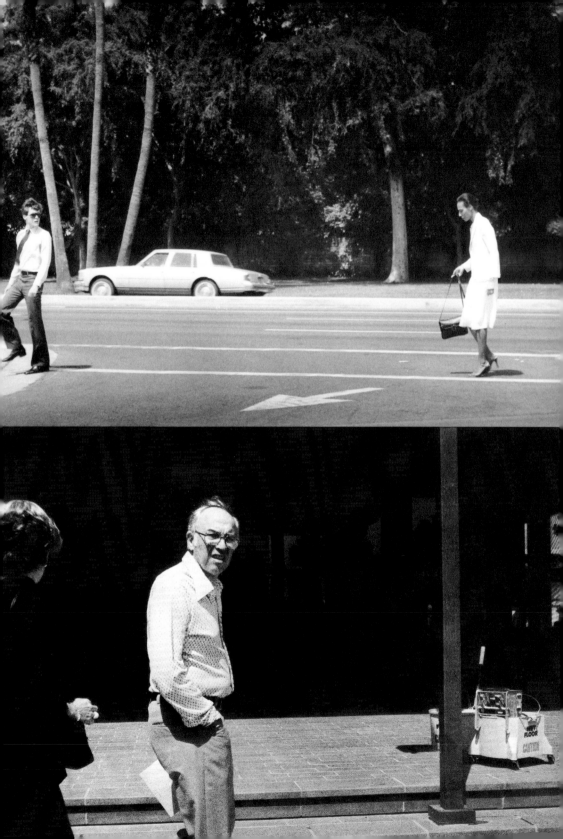

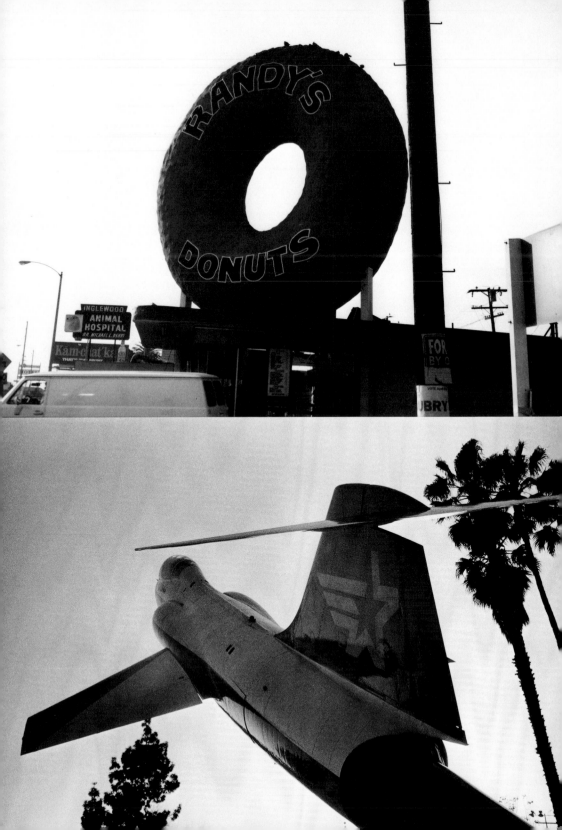

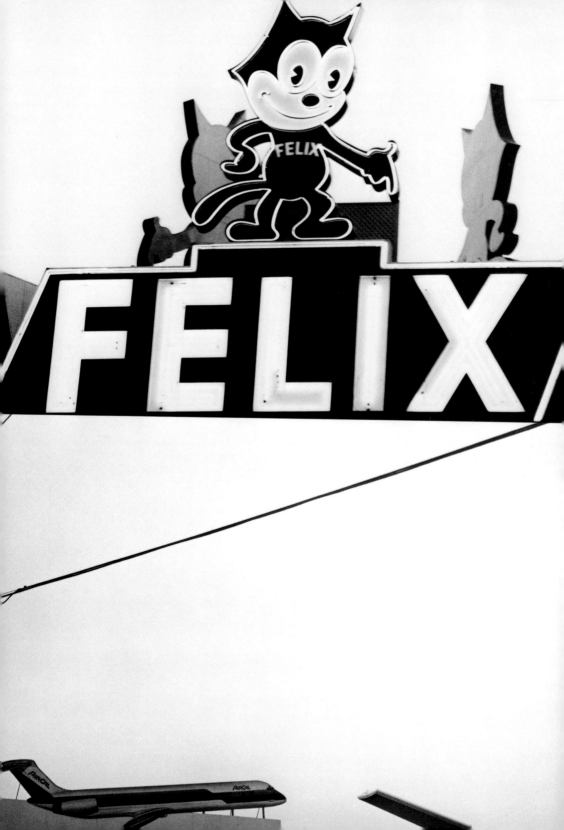

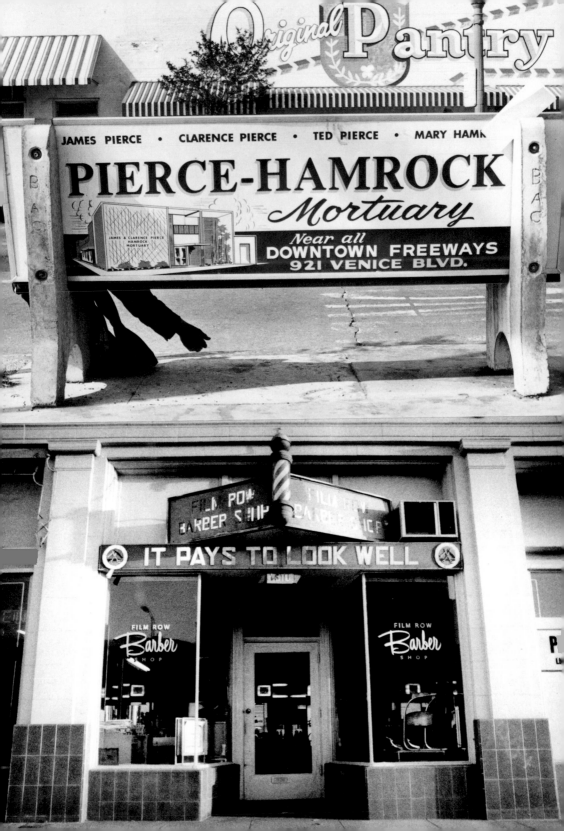

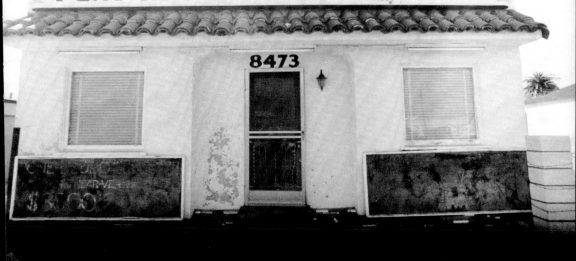

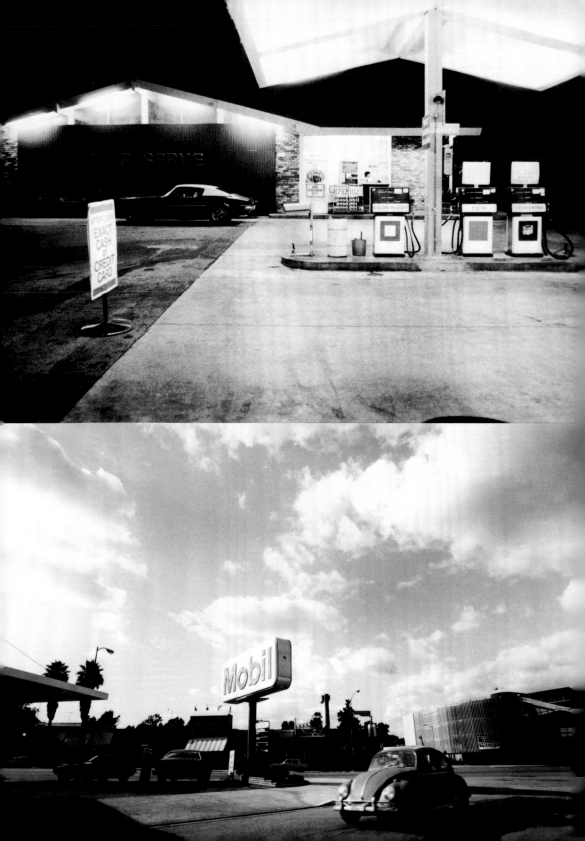

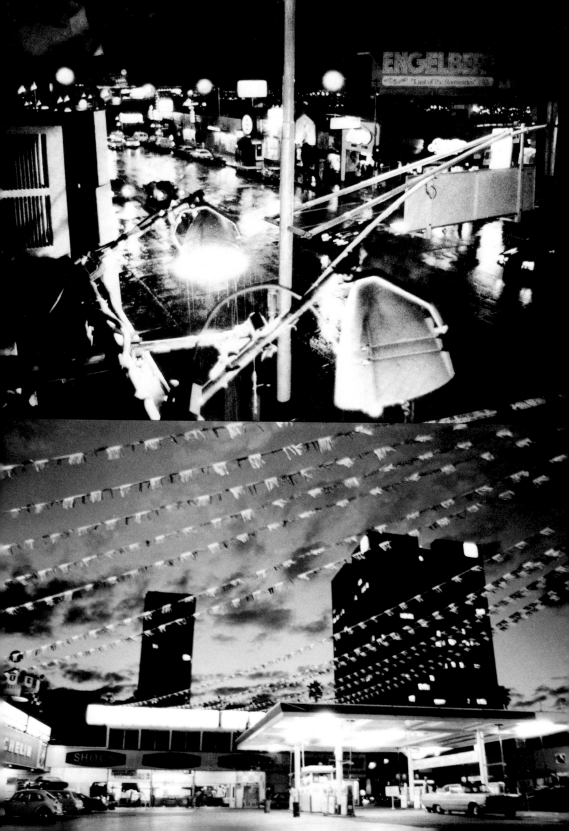

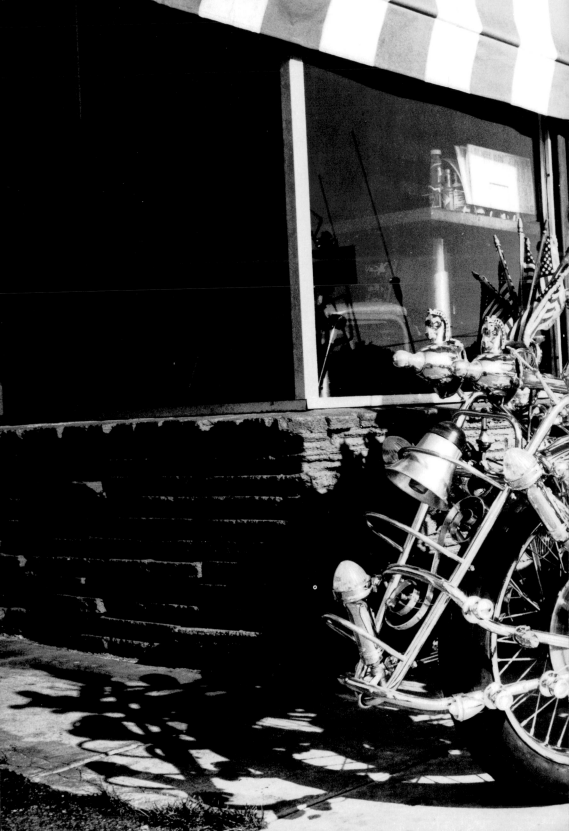

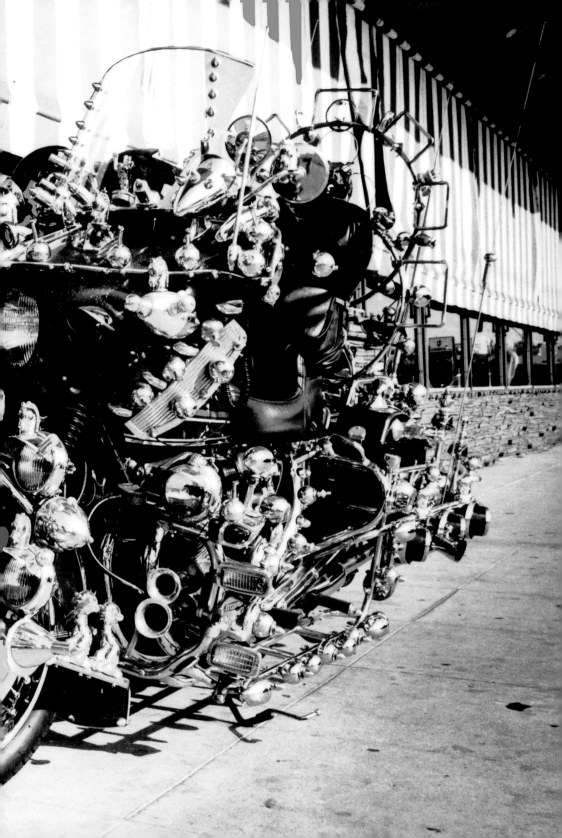

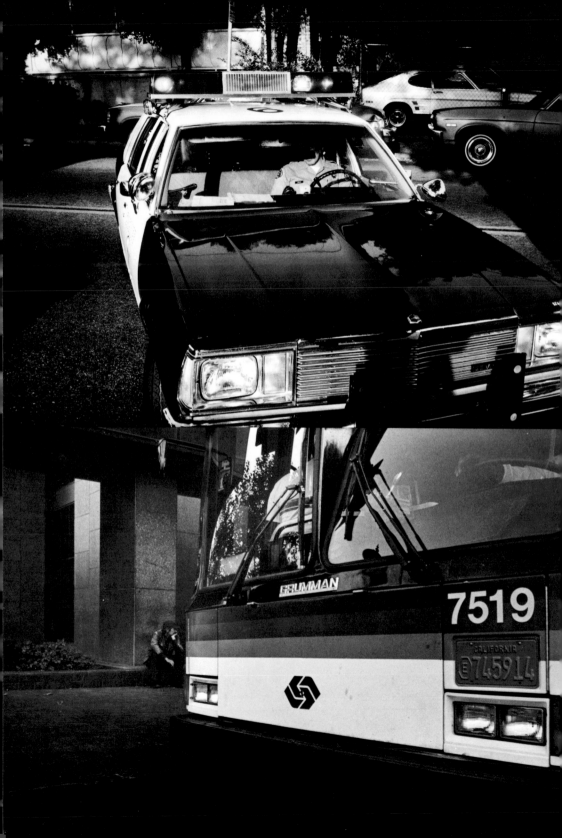

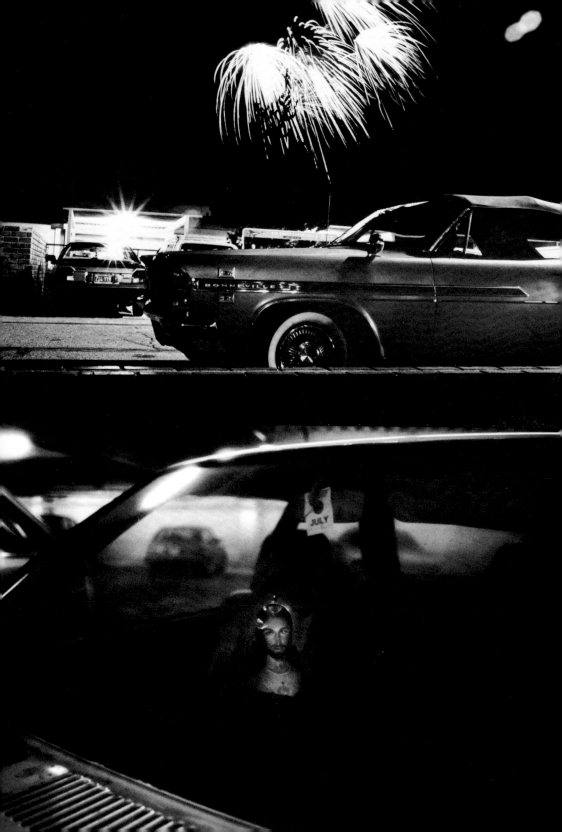

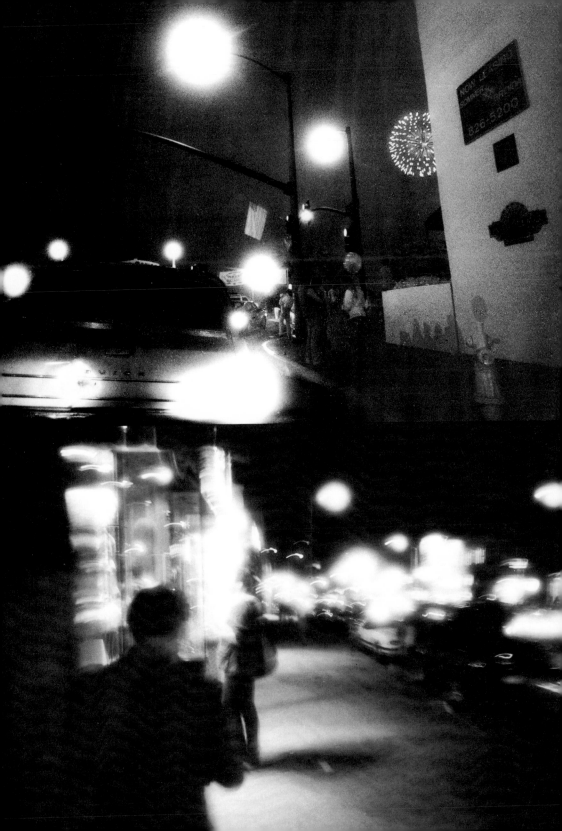